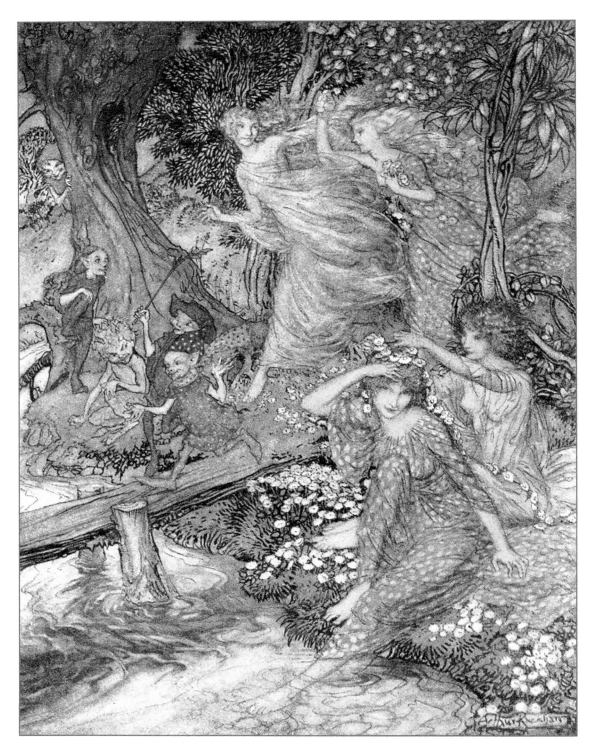

By dimpled Brook, and Fountain brim,
The Wood-Nymphs, deckt with Daisies trim,
Their merry wakes and pastimes keep.
[FRONTISPIECE]
Comus, 1921

Rackham's Fairies, Elves & Goblins

More than 80 Full-Color Illustrations

Selected and Edited by
JEFF A. MENGES

DOVER PUBLICATIONS, INC.,
MINEOLA, NEW YORK

Bibliographical Note

This Dover edition, first published in 2008, is an original compilation of illustrations from the following works: *Rip Van Winkle* (published by William Heinemann, Ltd., London, and Doubleday, Page & Co., 1905); *Puck of Pook's Hill* (published by Doubleday, Page & Co, 1906); *Alice's Adventures in Wonderland* (published by William Heinemann, Ltd., London, and Doubleday, Page & Co., 1907); *The Ingoldsby Legends: or Mirth and Marvels* (published by J. M. Dent & Co., London, and Doubleday, Page & Co., 1907); *A Midsummer-Night's Dream* (published by William Heinemann, Ltd., London, and Doubleday, Page & Co., 1908); *Tales from Shakespeare* (published by J. M. Dent & Co., London, and E. P. Dutton & Co., New York, 1907); *Undine* (published by William Heinemann, Ltd., London, and Doubleday, Page & Co., 1909); *Peter Pan in Kensington Gardens* (published by Hodder & Stoughton, London, and Charles Scribner's Sons, New York, 1912); *Aesop's Fables* (published by William Heinemann, Ltd., London, and Doubleday, Page & Co., 1912); *Arthur Rackham's Book of Pictures* (published by William Heinemann, Ltd., London, and The Century Co., New York, 1913); *Mother Goose: The Old Nursery Rhymes* (published by William Heinemann, Ltd., London and New York, 1913); *English Fairy Tales* (published by Macmillan Company, London and New York, 1918); *Some British Ballads* (published by Constable & Co., 1918); *Comus* (published by William Heinemann, Ltd., London, and Doubleday, Page & Co., 1921); and *A Wonder Book* (published by Hodder & Stoughton, London, and George H. Doran Co., 1922). A new Introduction has been specially prepared for the present edition.
NOTE: Caption punctuation varies according to the original source.

Library of Congress Cataloging-in-Publication Data

Rackham, Arthur, 1867–1939.
 Rackham's fairies, elves and goblins : more than 80 full-color illustrations / selected and edited by Jeff A. Menges.
 p. cm.
 ISBN-13: 978-0-486-46023-9
 ISBN-10: 0-486-46023-1
 1. Rackham, Arthur, 1867–1939. 2. Fairies in art. I. Menges, Jeff A. II. Title.

NC978.5.R32A4 2008
741.6'4092—dc22

 2007035597

Manufactured in the United States by Courier Corporation
46023103 2013
www.doverpublications.com

TO JESSICA

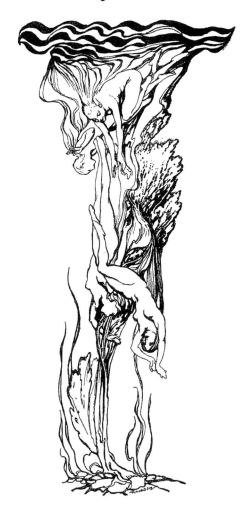

INTRODUCTION

One of the premier artists of the Golden Age of Illustration (the 1880s through the 1920s), Arthur Rackham was born in London in 1867. He began building his artistic reputation while a student at the City of London School. In his late teens he accepted a clerical position, but he continued to draw and paint, and took up studies at the Lambeth School of Art. Rackham's first forays into the world of professional illustration began when his pieces were included in the *Pall Mall Budget* weekly, and by 1892 he had committed himself to a full-time artistic career. Exploring a variety of styles early on, Rackham contributed illustrations to various publications for the next few years; his first commissioned work came in 1896. Success built upon success, and soon he was producing images for numerous books and children's magazines. His career flourished throughout the early decades of the twentieth century, and he joined the distinguished company of the likes of Walter Crane and Kate Greenaway—and proved a leader in new illustration markets and an inspiration for Edmund Dulac and Charles Robinson, among others. After a long and prolific career, Arthur Rackham died in 1939.

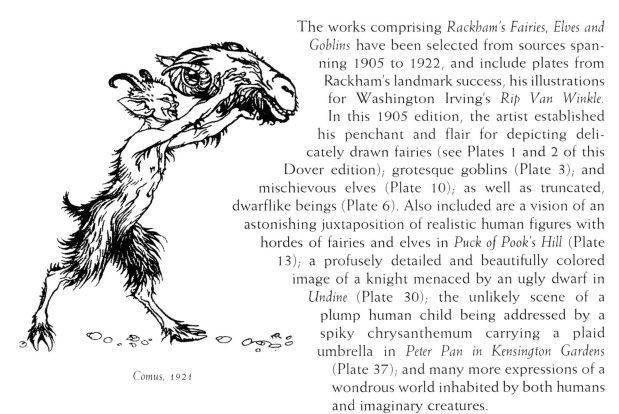

Comus, 1921

The works comprising *Rackham's Fairies, Elves and Goblins* have been selected from sources spanning 1905 to 1922, and include plates from Rackham's landmark success, his illustrations for Washington Irving's *Rip Van Winkle.* In this 1905 edition, the artist established his penchant and flair for depicting delicately drawn fairies (see Plates 1 and 2 of this Dover edition); grotesque goblins (Plate 3); and mischievous elves (Plate 10); as well as truncated, dwarflike beings (Plate 6). Also included are a vision of an astonishing juxtaposition of realistic human figures with hordes of fairies and elves in *Puck of Pook's Hill* (Plate 13); a profusely detailed and beautifully colored image of a knight menaced by an ugly dwarf in *Undine* (Plate 30); the unlikely scene of a plump human child being addressed by a spiky chrysanthemum carrying a plaid umbrella in *Peter Pan in Kensington Gardens* (Plate 37); and many more expressions of a wondrous world inhabited by both humans and imaginary creatures.

What made Arthur Rackham one of the most revered illustrators of the twentieth century was his individuality; his unique and soulful line quality has allowed his work to endure the test of time. Coming into his artistic career when line art was used almost exclusively for reproduction, Rackham carried his consummate skills for composition with tone into his color work. It was, however, his line technique that would carry his imagery, and it is this facility that impresses us when we examine his work today. The life and personality that he imparted to his characterizations was an artistic achievement matched by few, if any, of his contemporaries. While Rackham

was a skilled line artist who could have taken up more commercial tasks—rendering images into line art for newspapers and illustrated magazines of the day—he had great distaste for working with mundane subjects. Because he did not take a more commercial path, choosing instead to select assignments that reflected his own interest in their subject matter (such as fairy tales or literary works), he was able to put such feeling and personality into his work.

Rackham's ability to visually represent the imaginary was far ranging, from the image of the slightest Midsummer fairy (Plate 18) to the intricate, ferocious Dragon of the Hesperides (Plate 48). Rackham's characters speak to us through the artist's use of exaggeration, posture, and expression. It is the artist's careful manipulation of these elements that enables his creations to better tell a story; it also lets Rackham assign personality not only to his characters, both human and otherwise, but also to the landscape itself. Trees were a particular favorite, and when his texts gave him the slightest indication as to the demeanor of a forest, Rackham would have a creative field day, as many plates within this volume will attest. The example below, from Hawthorne's *A Wonder Book*, shows the expressive and human qualities that Rackham would often impart to his forest residents. Look carefully and you will detect ancient faces in the trees in Plates 16, 40, 41, and 59. Bare branches become claw-like, and rough bark easily displays features full of life and character. Couple this imagination with his incredibly expressive line, and Rackham's creatures speak with a unique visual voice, standing out from other illustrations of the period and making his work markedly distinct and easily identifiable. Each of the artist's pieces has its own technical merits: unique composition, earthy palate, and liquid line work. It is Rackham's wonderfully personal characters—and the stories they tell with the life he has given them—that we see when we look at works such as "The Little People's Market" (Plate 45), or the mischievous spirits in Rip Van Winkle's Catskill Mountains (Plates 7 and 8). Here is the full range of the artist's own creative menagerie, revealing to us a glimpse of the genius that brought them all to the printed page.

Jeff A. Menges
July 2007

A Wonder Book, 1922

LIST OF PLATES

Rackham's
Fairies, Elves & Goblins

More than 80 Full-Color Illustrations

THE PLATES

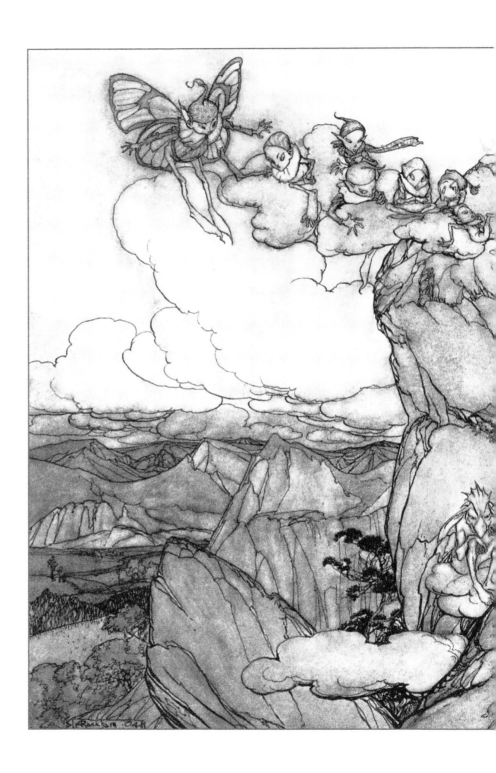

Plate 1 Rip Van Winkle

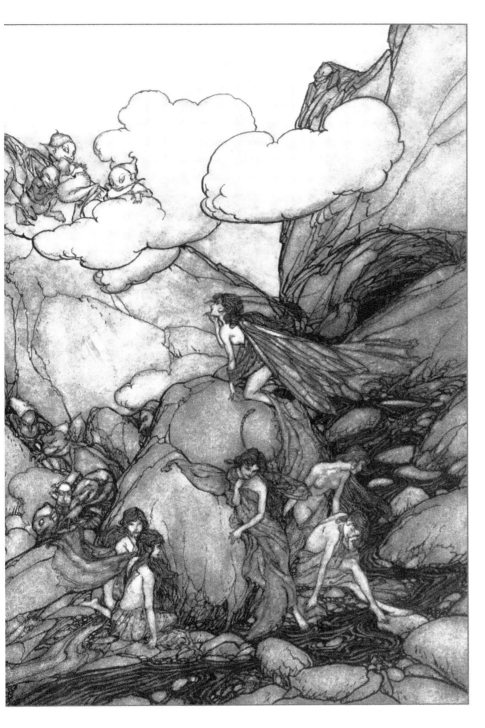

"These fairy mountains"

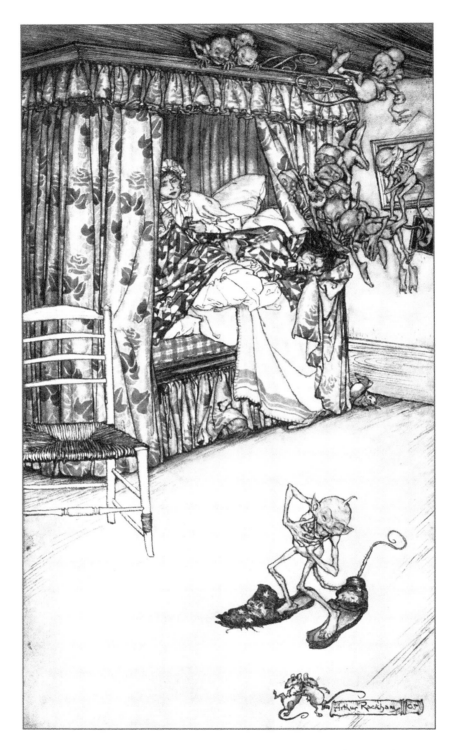

"A curtain-lecture is worth all the sermons in the world
for teaching the virtues of patience and long-suffering."

PLATE 3 Rip Van Winkle

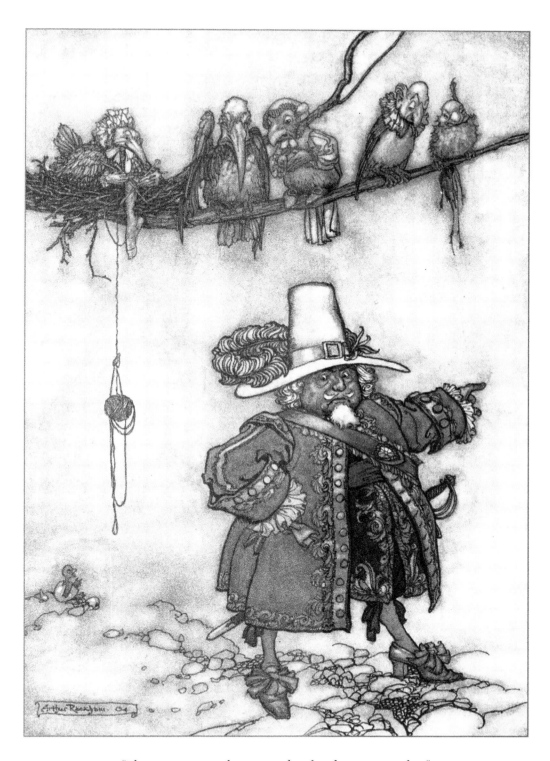

"There was one who seemed to be the commander."

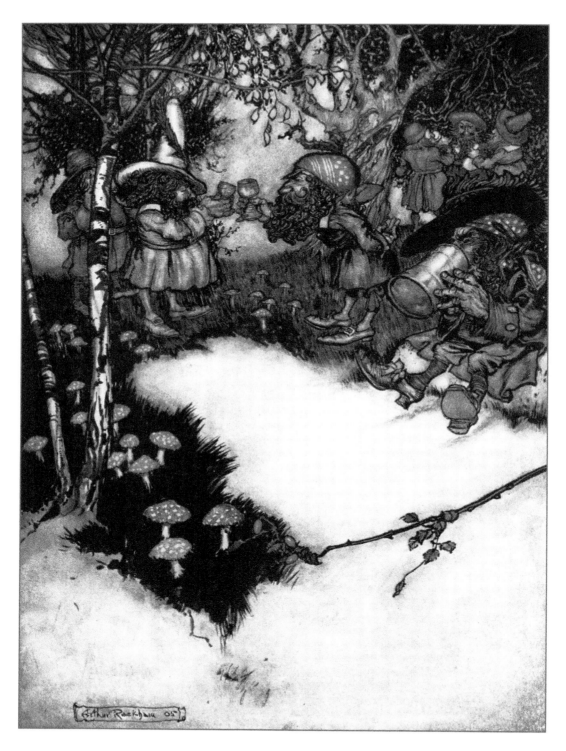

"They quaffed their liquor in profound silence."

PLATE 5 Rip Van Winkle

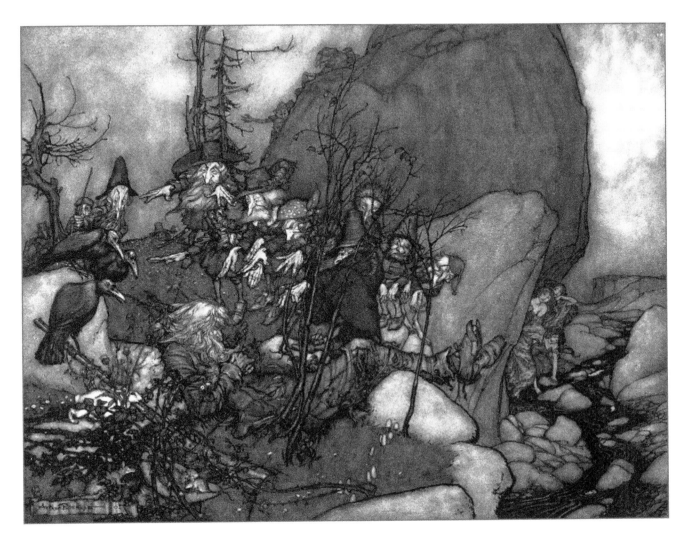

"The sleep of Rip Van Winkle."

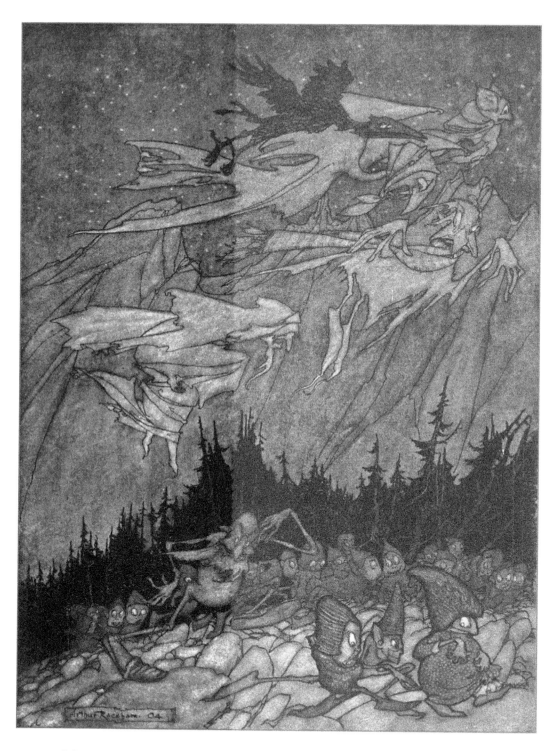

"The Kaatskill mountains had always been haunted by strange beings."

PLATE 7 Rip Van Winkle

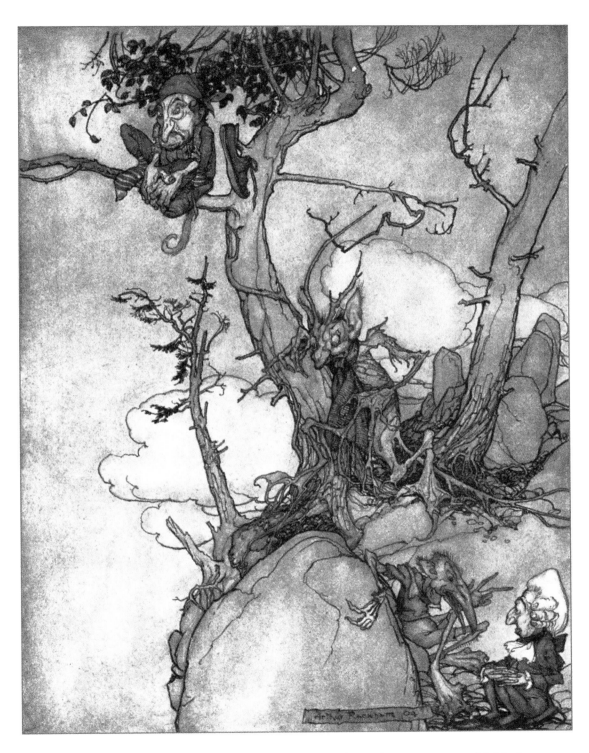

"The Kaatsberg or Catskill mountains have always been a region of fable."

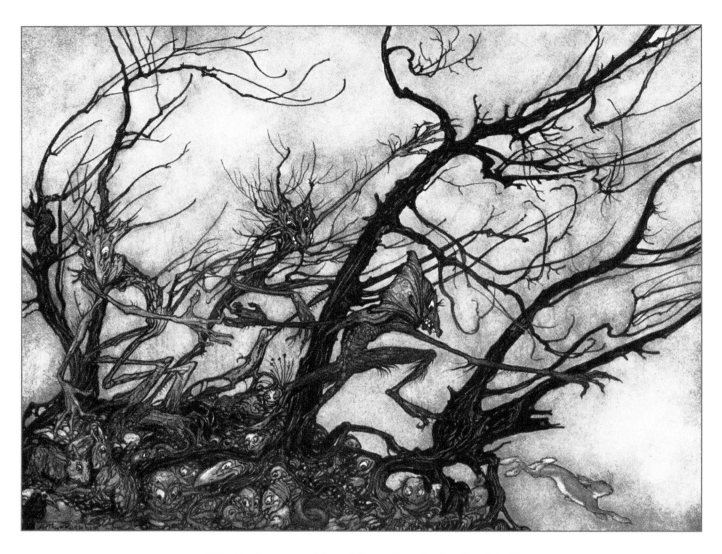

"The Indians considered them the abode of spirits."

PLATE 9 Rip Van Winkle

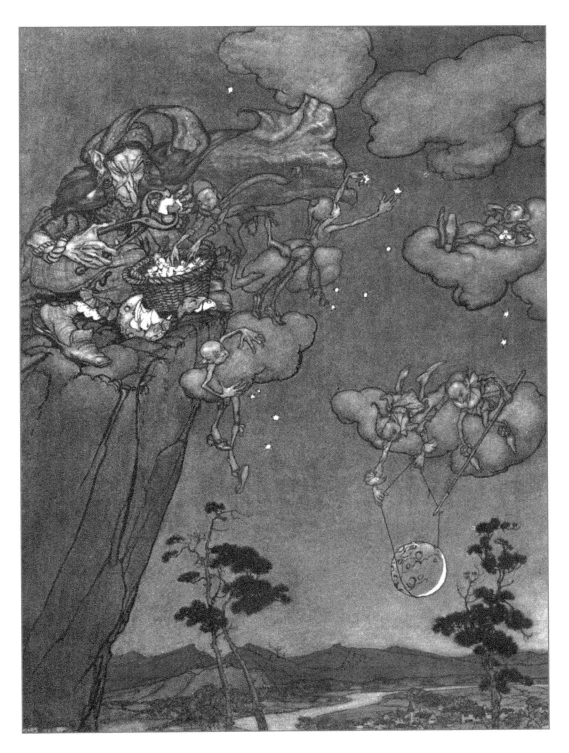

"They were ruled by an old squaw who hung up the new moons in the skies and cut up the old ones into stars."

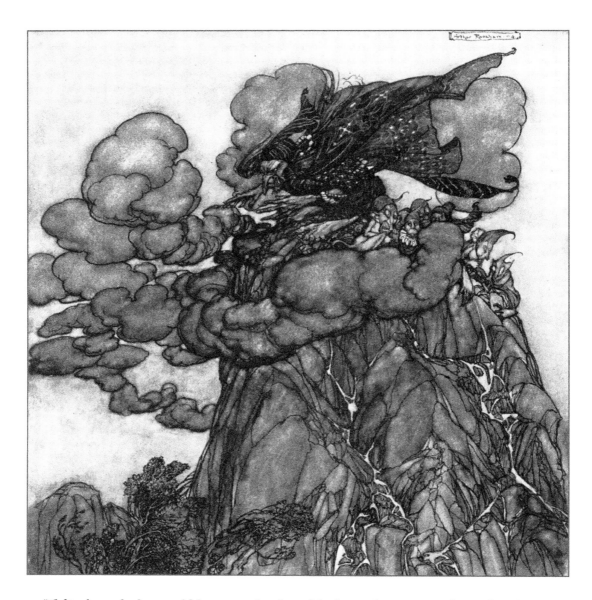

"If displeased, she would brew up clouds as black as ink, sitting in the midst of them like a bottle-bellied spider in the midst of its web: and when these clouds broke, woe betide the valleys!"

PLATE 11 Rip Van Winkle

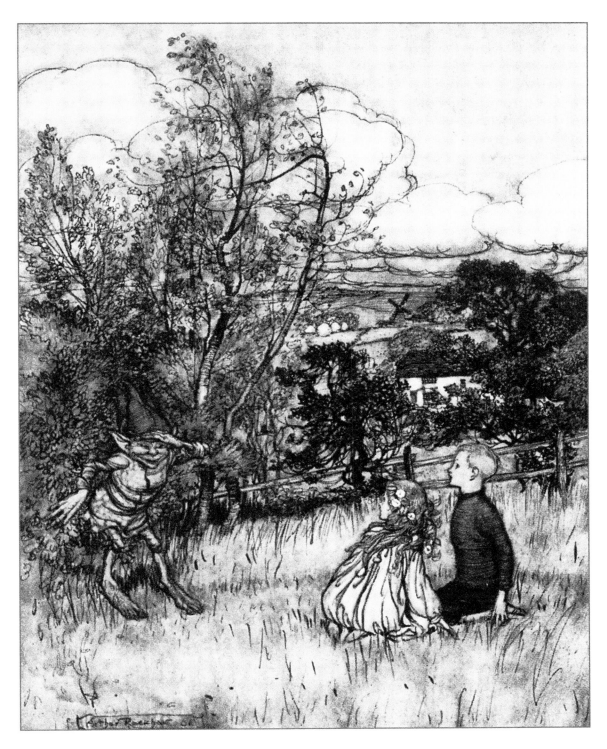

In the very spot where Dan had stood as Puck they saw a small, brown,
broad-shouldered, pointy-eared person with a snub nose, slanting blue eyes,
and a grin that ran right across his freckled face.

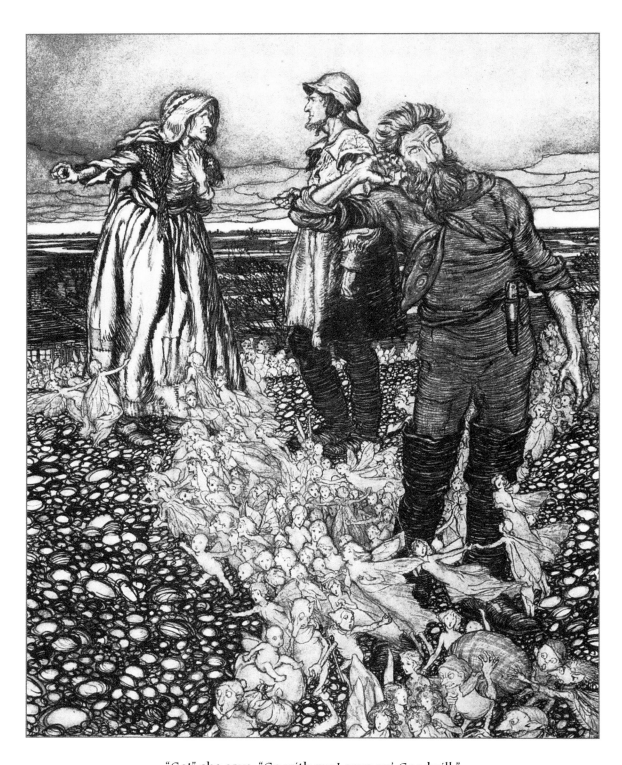

"Go!" she says, "Go with my Leave an' Goodwill."

PLATE 13 Puck of Pook's Hill

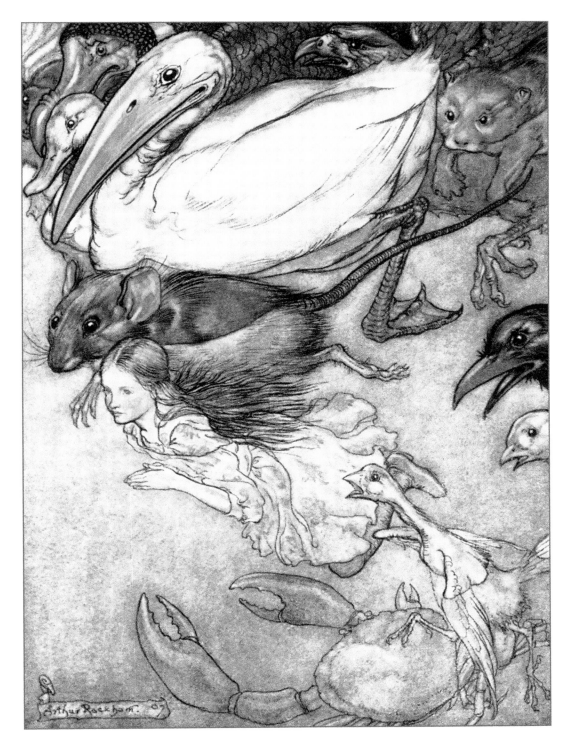

The Pool of Tears

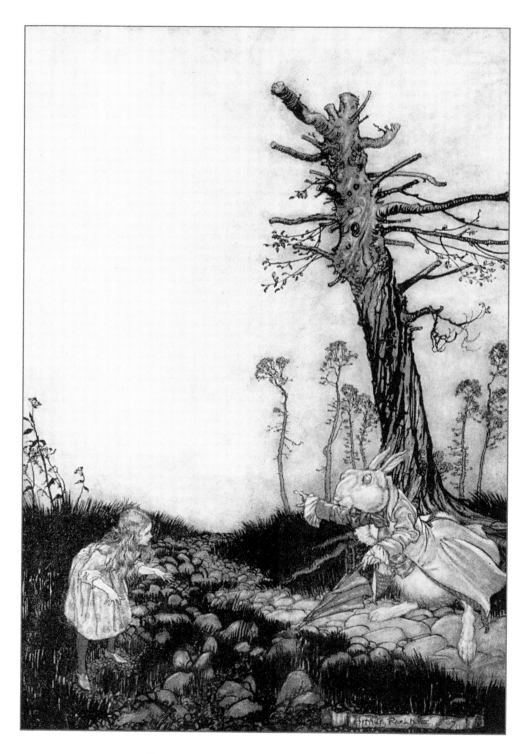

Why, Mary Ann, what are you doing here?

PLATE 15 Alice's Adventures in Wonderland

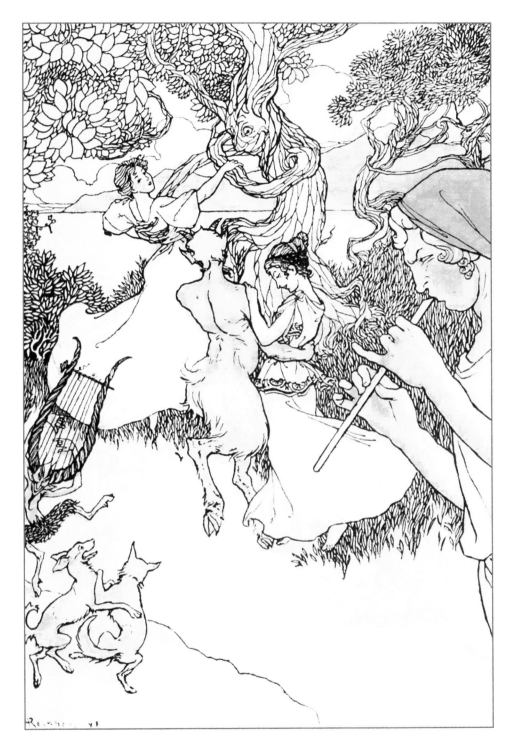

If Orpheus first produced the Waltz

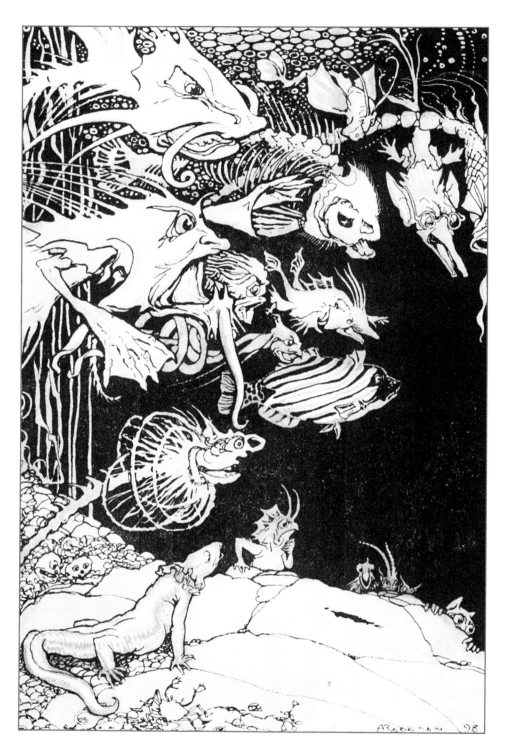

They's such very odd heads and such very odd tales

PLATE 17 The Ingoldsby Legends

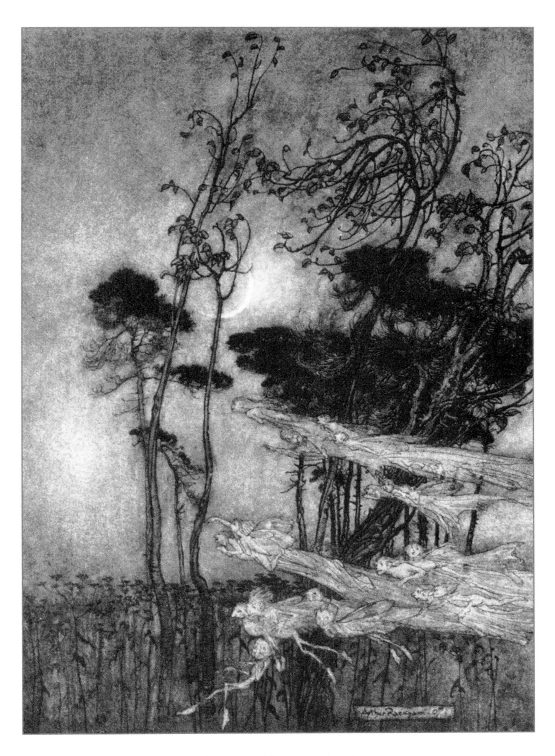

. . . the moon, like to a silver bow
New-bent in heaven

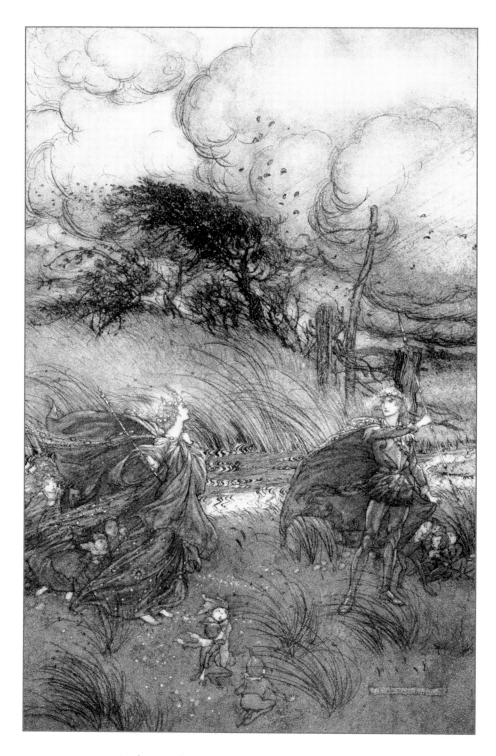

And now they never meet in grove or green,
By fountain clear, or spangled starlight sheen
But they do square

PLATE 19 A Midsummer-Night's Dream

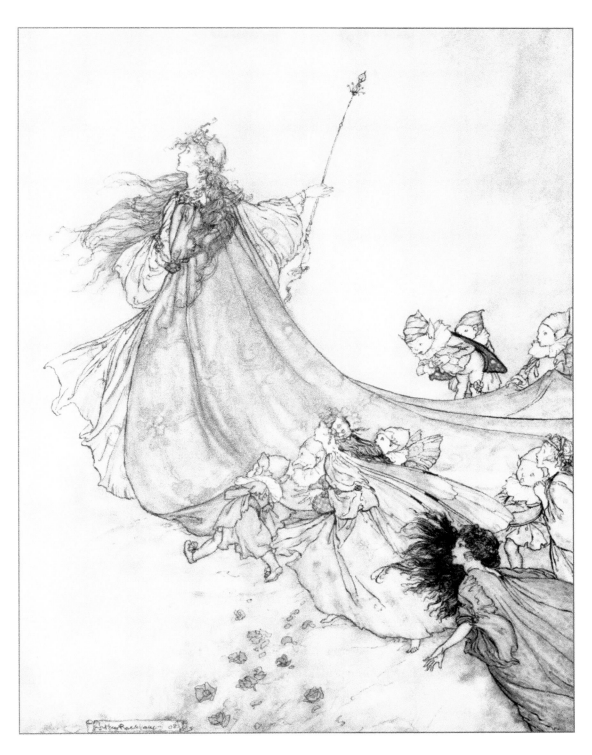

Fairies, away!
We shall chide downright, if I longer stay

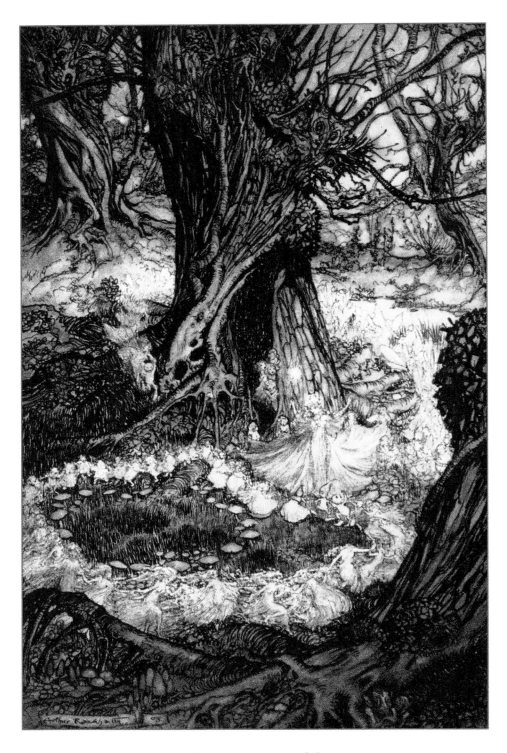

Come, now a roundel

PLATE 21 A Midsummer-Night's Dream

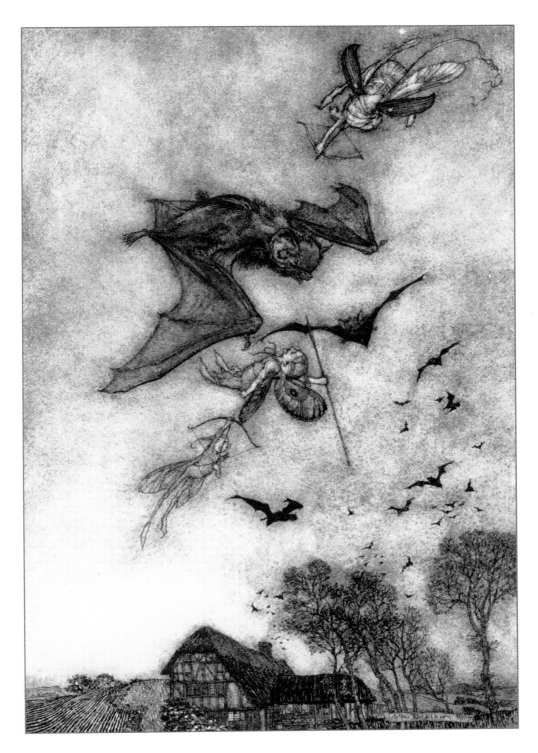

Some war with rere-mice for their leathern wings

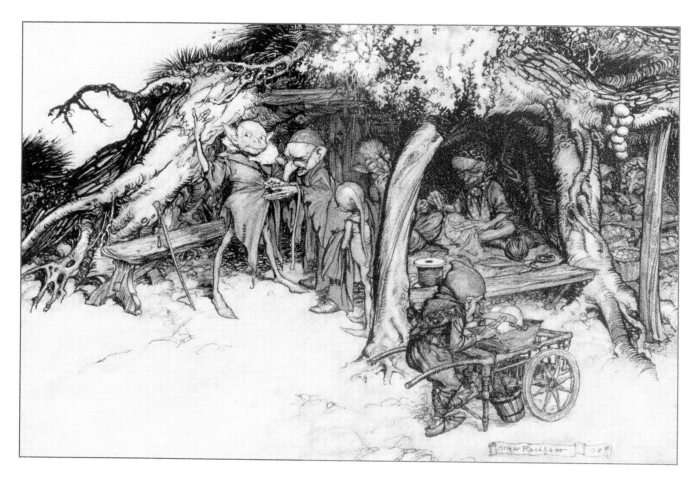

To make my small elves coats

PLATE 23 A Midsummer-Night's Dream

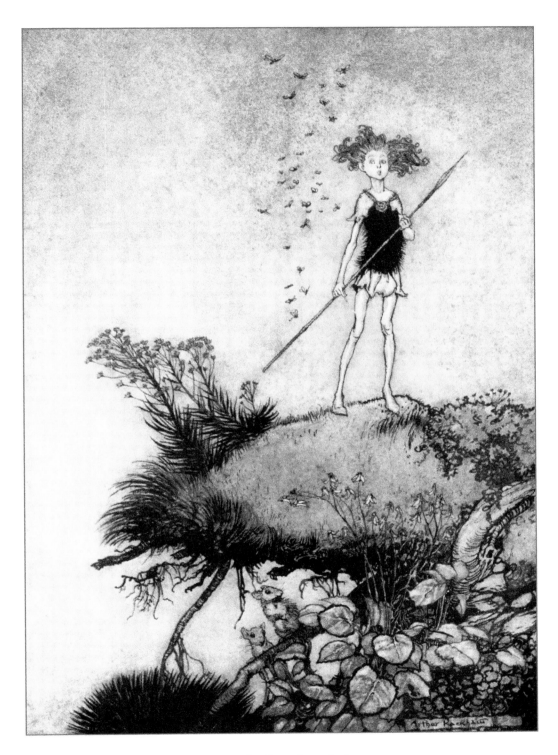

One aloof stand sentinel

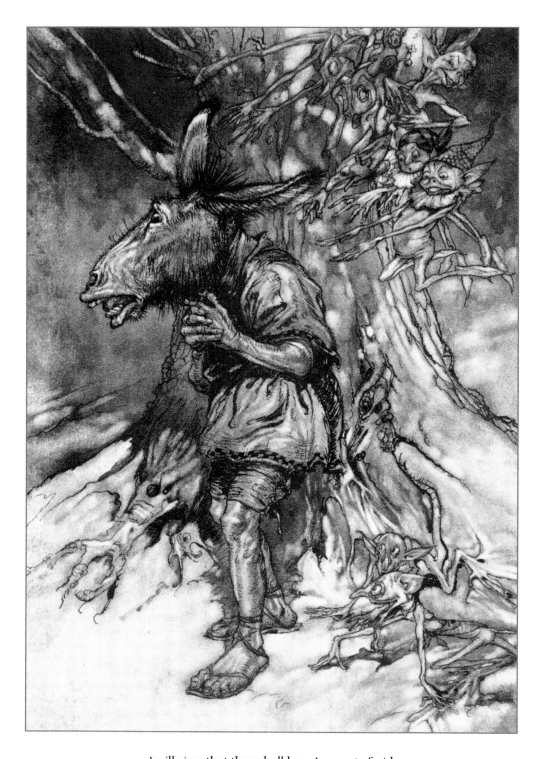

I will sing, that they shall hear I am not afraid

PLATE 25 A Midsummer-Night's Dream

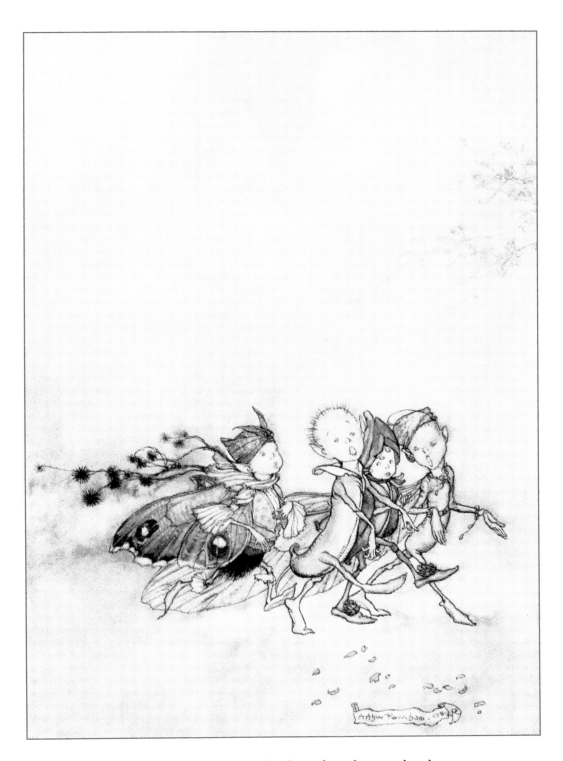

Enter Peaseblossom, Cobweb, Moth, and Mustardseed

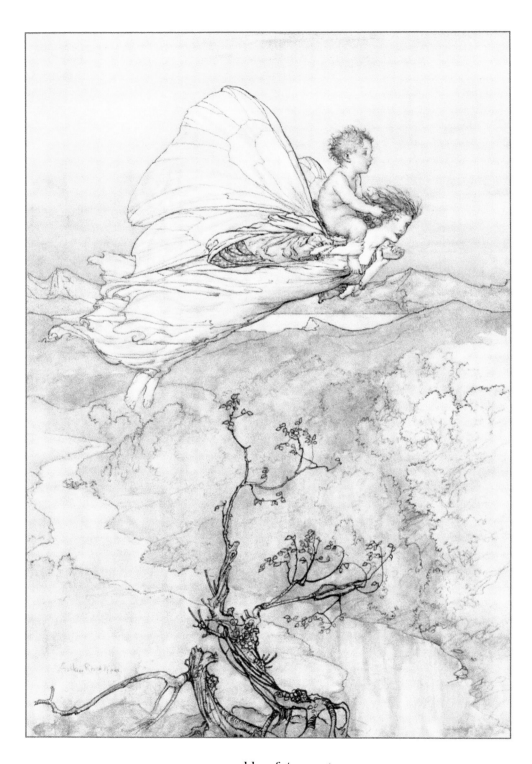

. . . and her fairy sent
To bear him to my bower in fairy land

PLATE 27 A Midsummer-Night's Dream

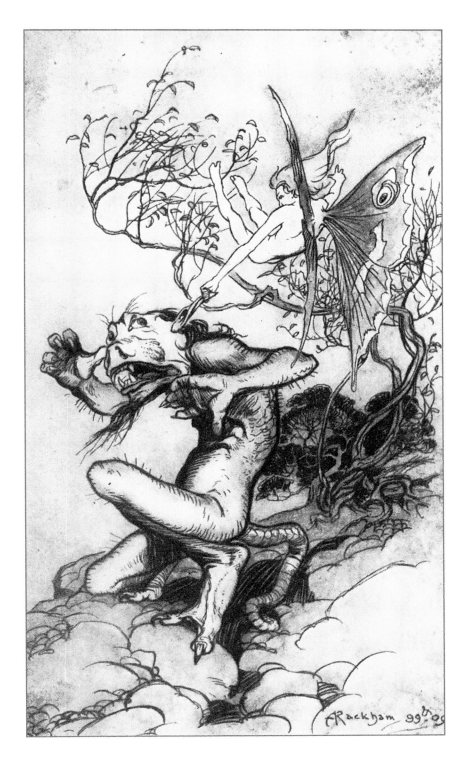

When Caliban was lazy and neglected his work,
Ariel would come silly and pinch him

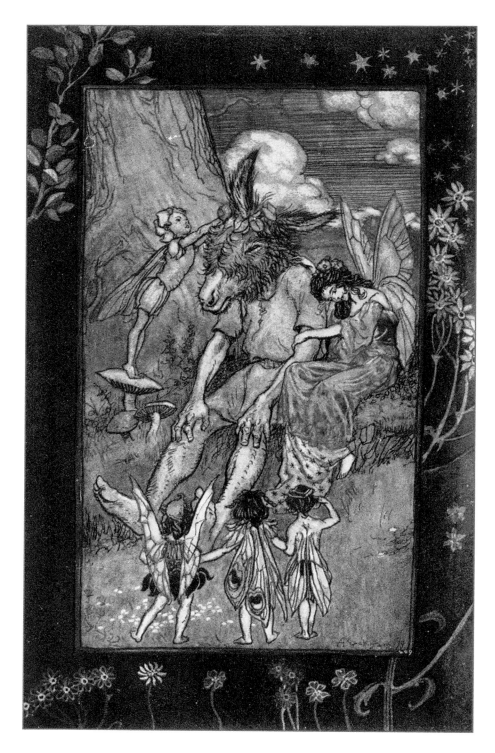

Where is Pease-Blossom?

PLATE 29 Tales from Shakespeare

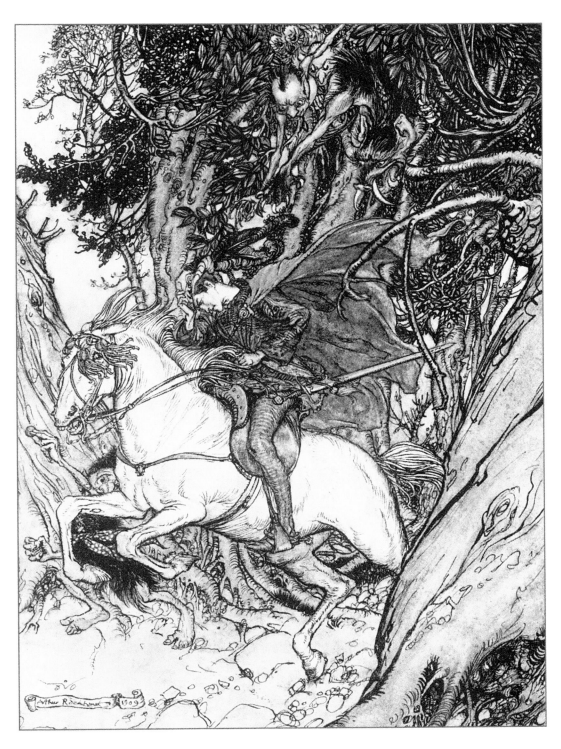

He held up the gold piece, crying at each leap of his,
"False gold! false coin! false coin!"

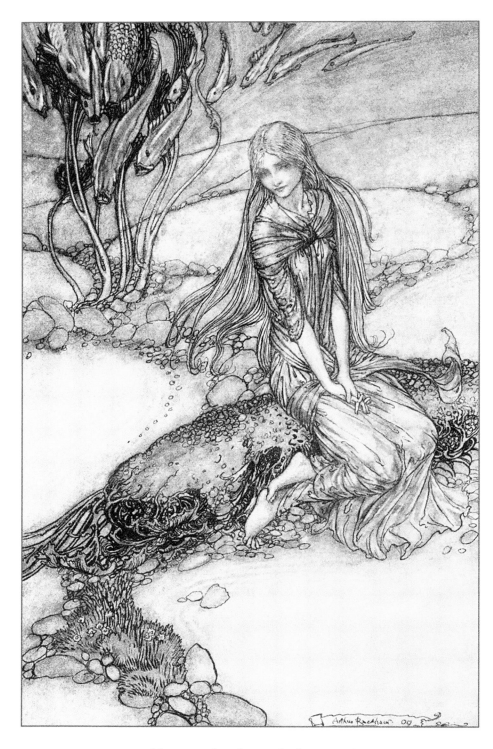

He could see Undine beneath the crystal vault

PLATE 31 Undine

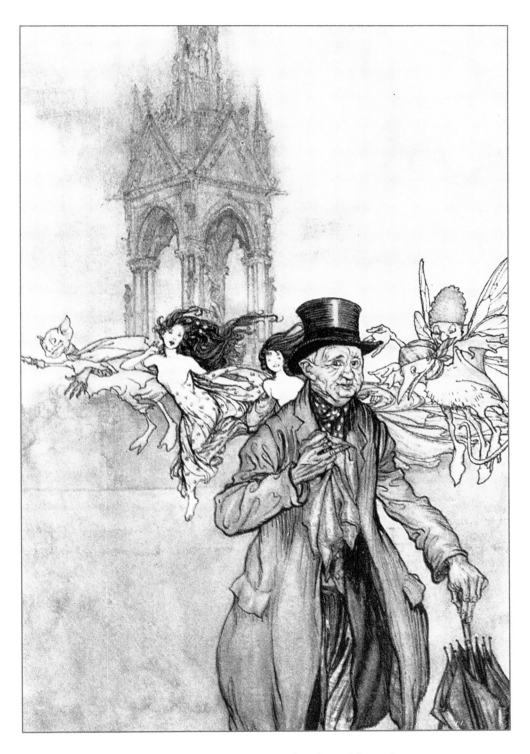

Old Mr. Salford was a crab-apple of an old gentleman
who wandered all day in the gardens.

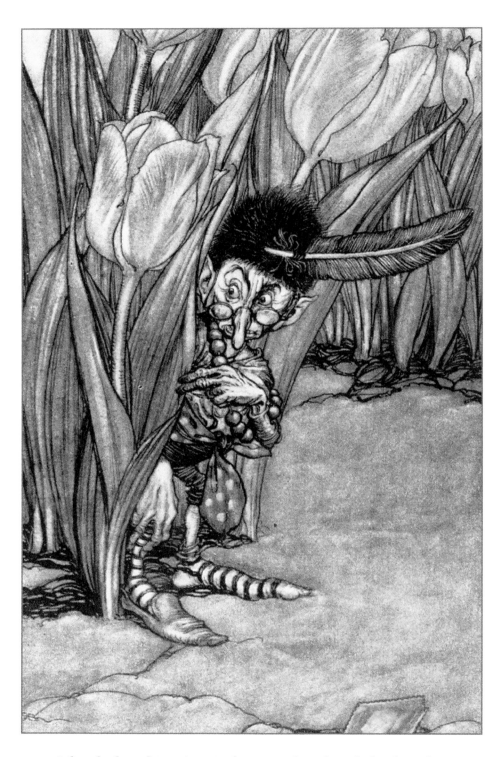

When he heard Peter's voice he popped in alarm behind a tulip.

PLATE 33 Peter Pan in Kensington Gardens

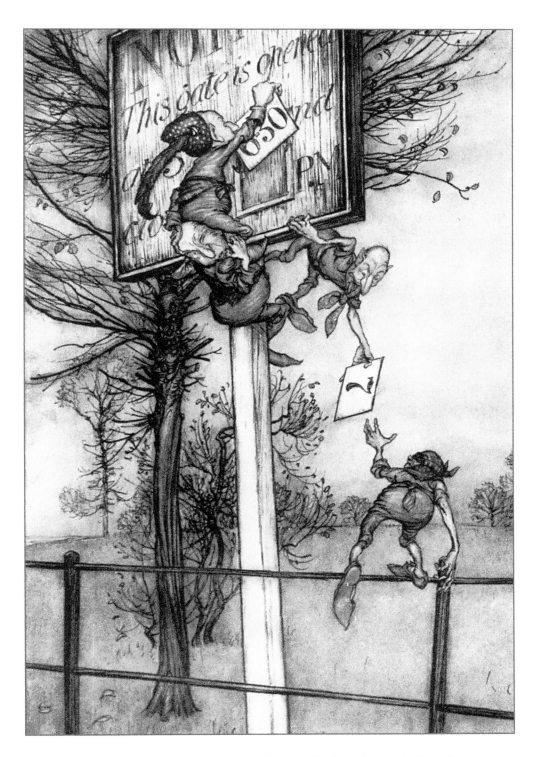

These tricky fairies sometimes change the board on a ball night.

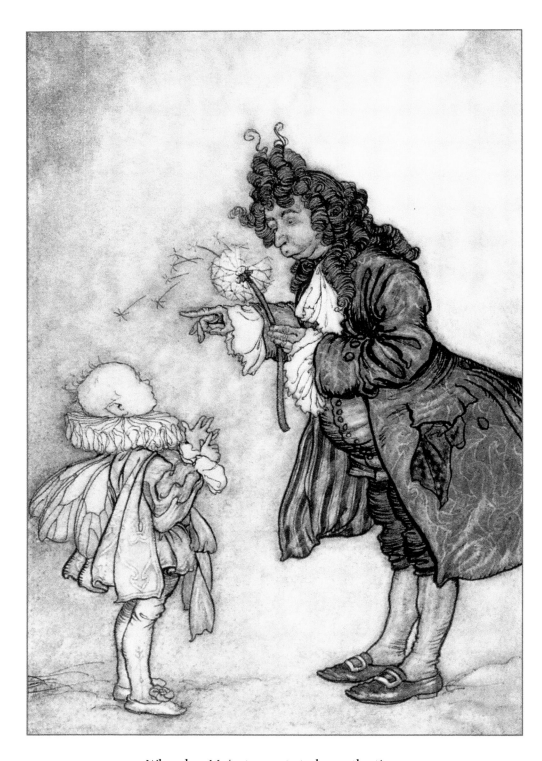

When her Majesty wants to know the time.

PLATE 35 Peter Pan in Kensington Gardens

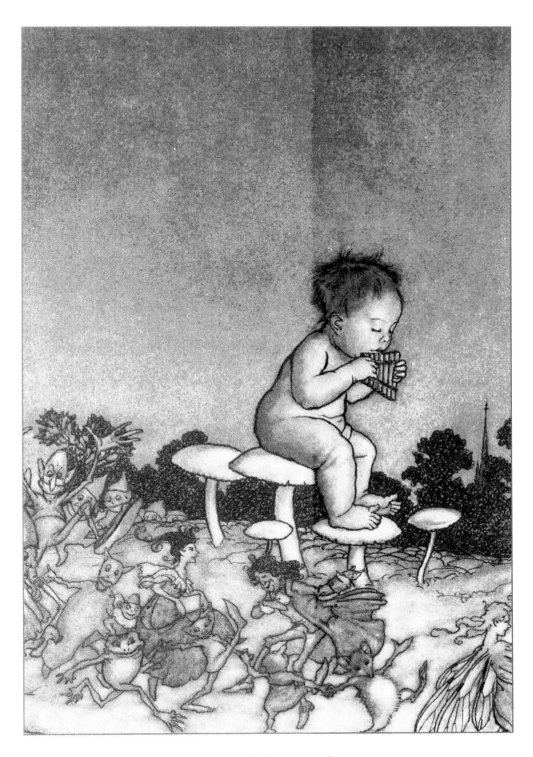

Peter Pan is the fairies' orchestra.

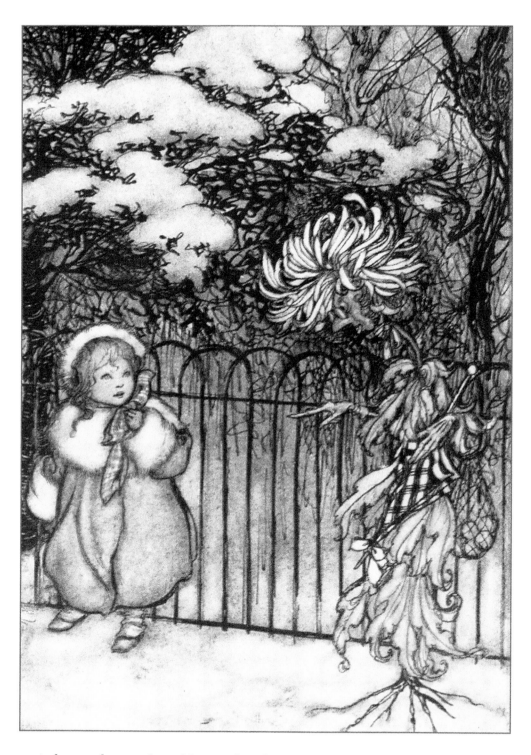

A chrysanthemum heard her, and said pointedly, "Hoity-toity, what is this?"

PLATE 37　Peter Pan in Kensington Gardens

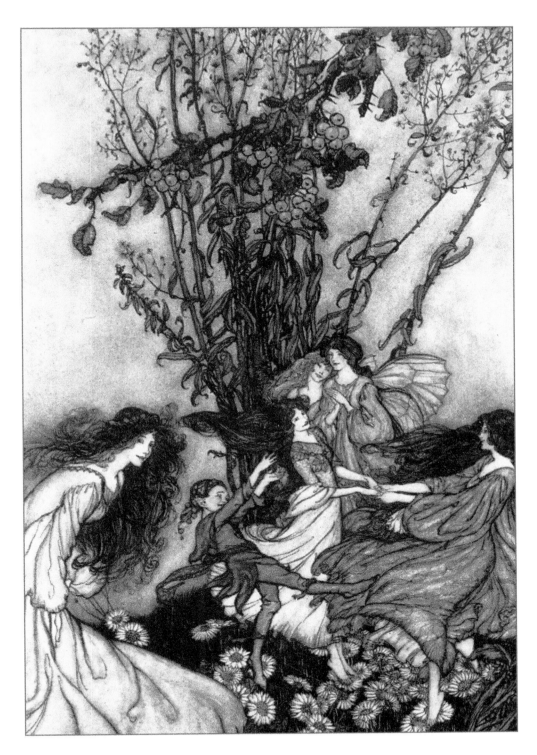

Fairies never say, "We feel happy"; what they say is, "We feel dancey."

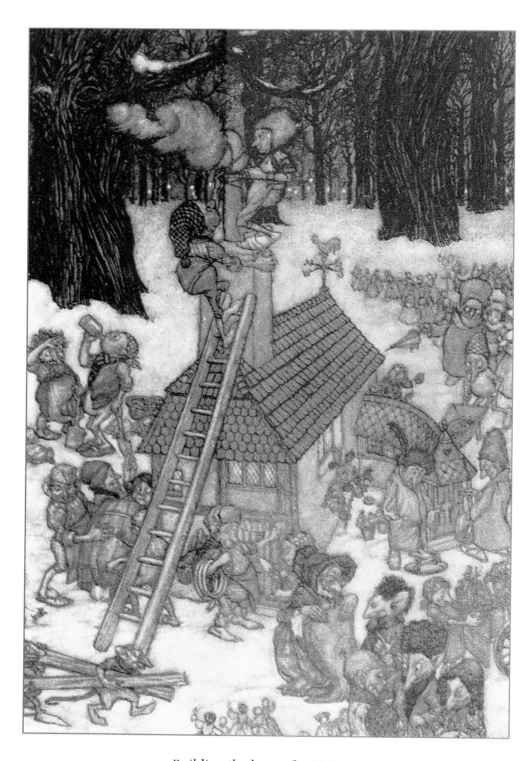

Building the house for Maimie.

PLATE 39 Peter Pan in Kensington Gardens

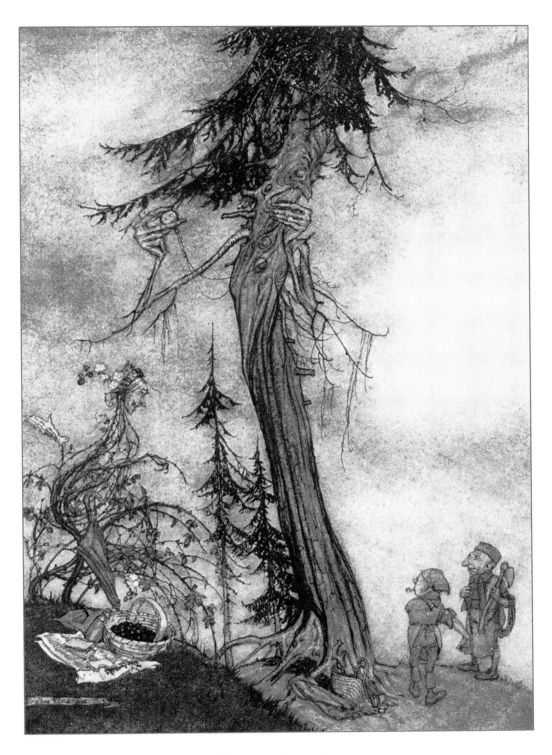

The fir-tree and the Bramble

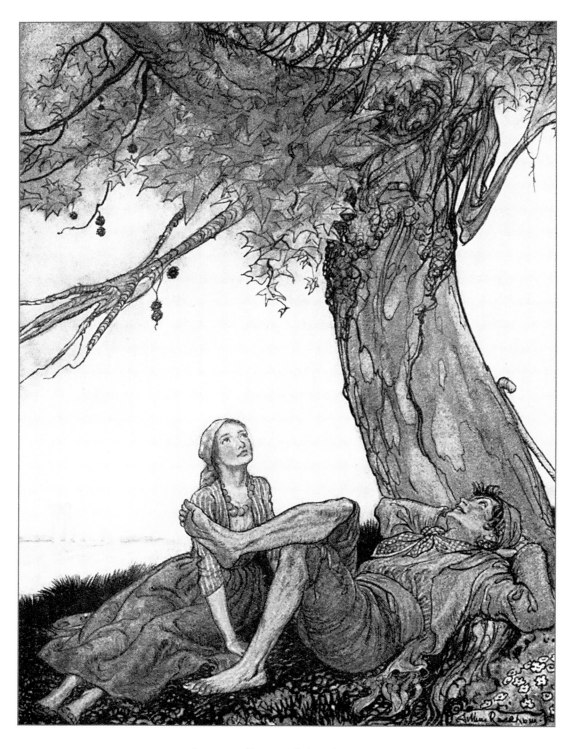

The Travellers and the Plane-tree

PLATE 41 Aesop's Fables

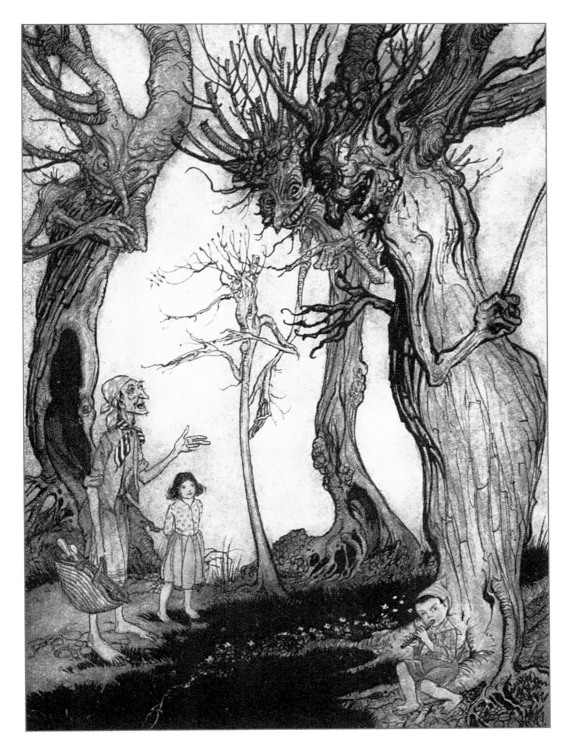

The trees and the axe

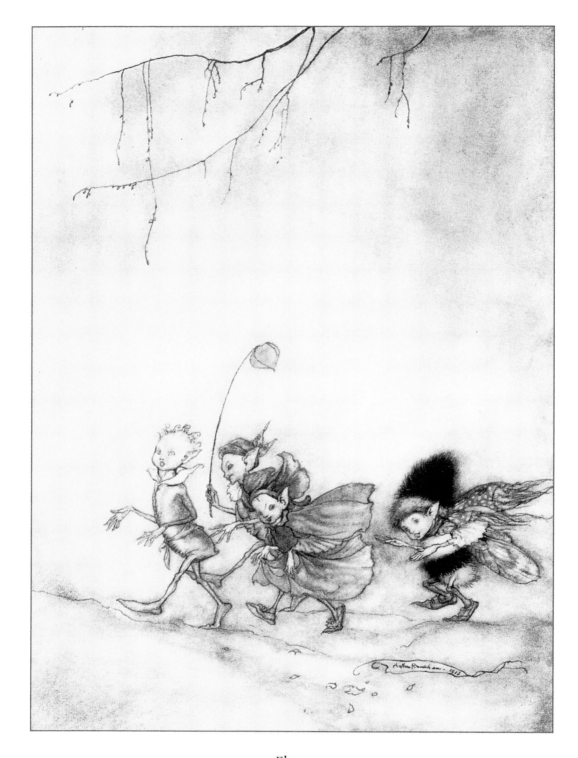

Elves

PLATE 43 Arthur Rackham's Book of Pictures

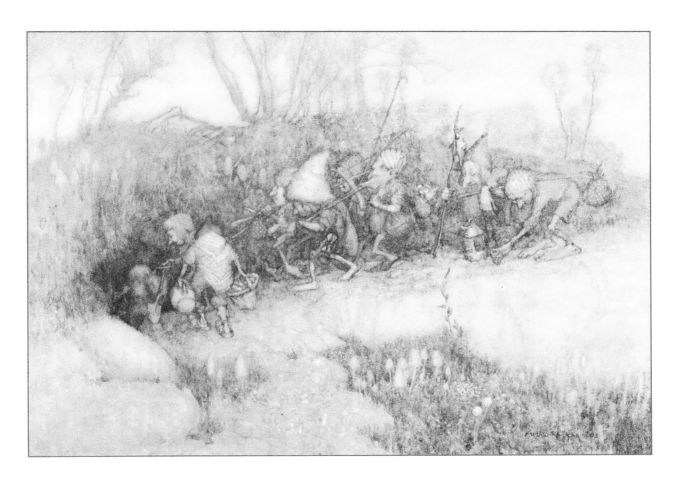

Seekers for Treasure

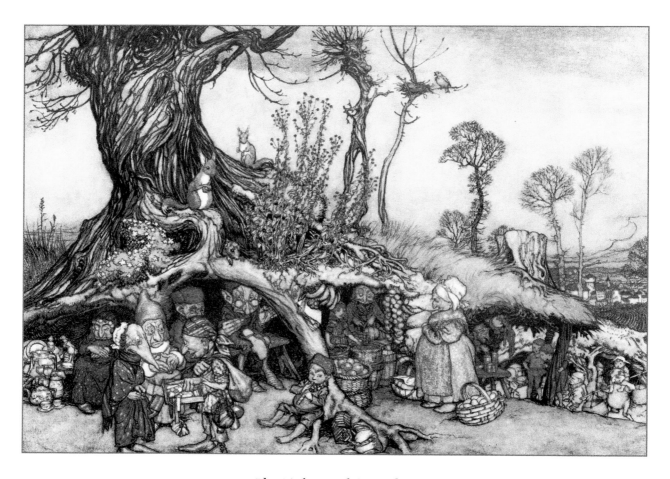

The Little People's Market

PLATE 45 Arthur Rackham's Book of Pictures

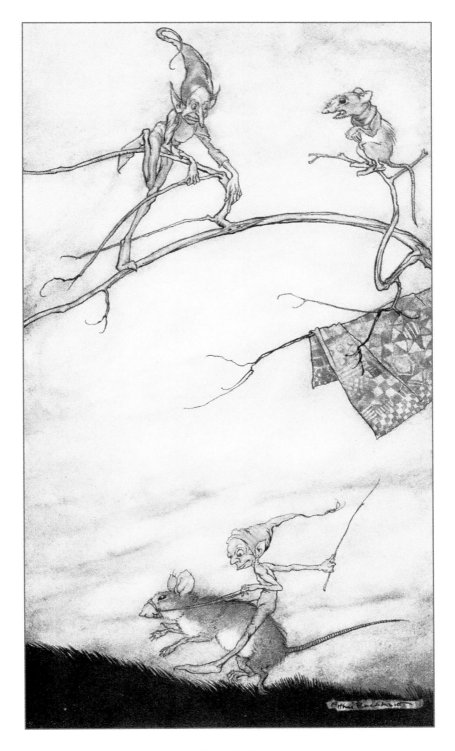

Wee Folk

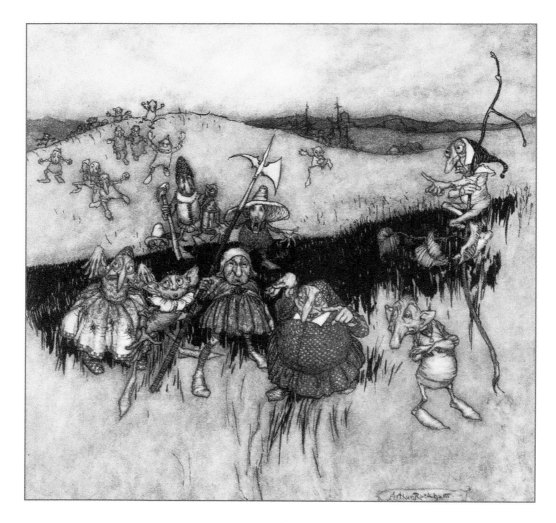

Malice

PLATE 47 Arthur Rackham's Book of Pictures

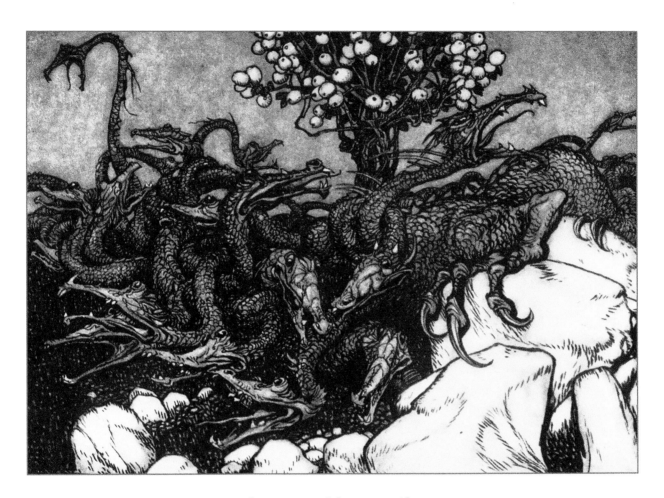

The Dragon of the Hesperides

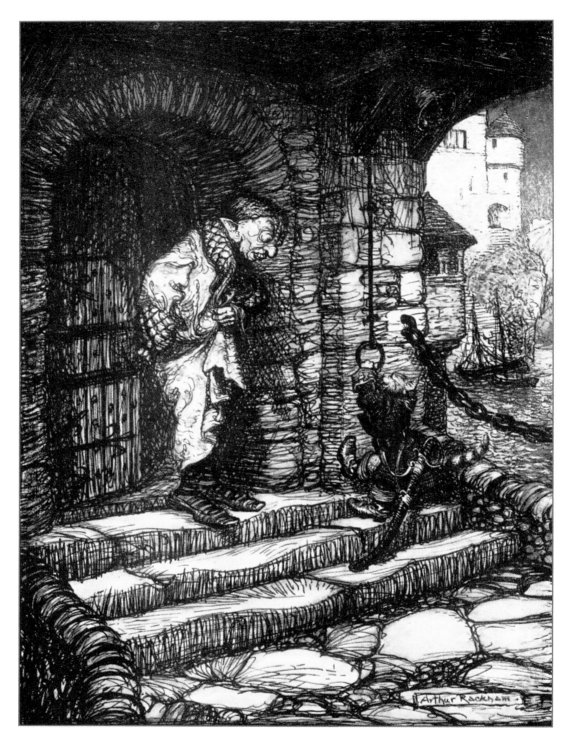

Puss in Boots

PLATE 49 Arthur Rackham's Book of Pictures

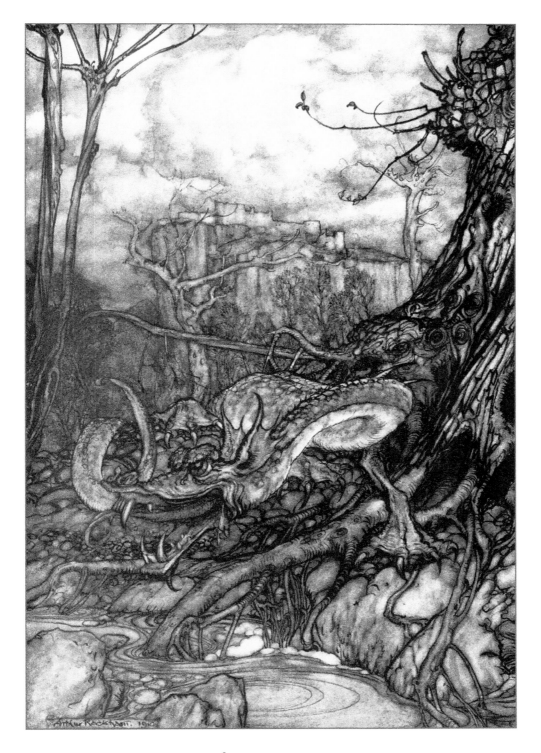

The Green Dragon

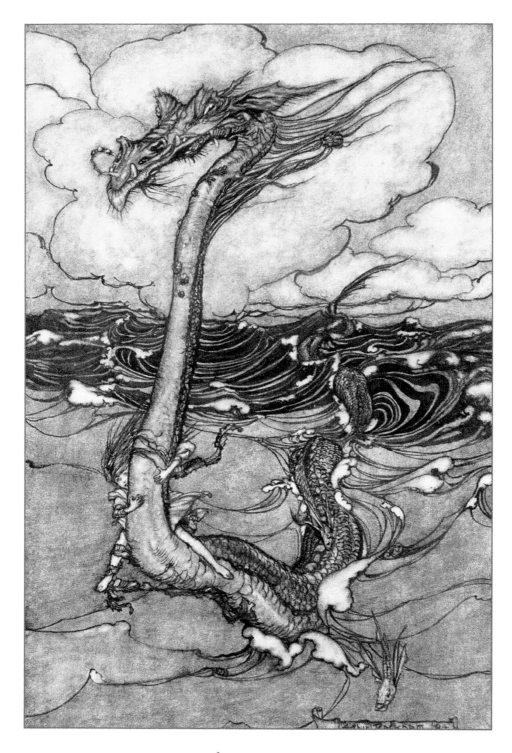

The Sea Serpent

PLATE 51 Arthur Rackham's Book of Pictures

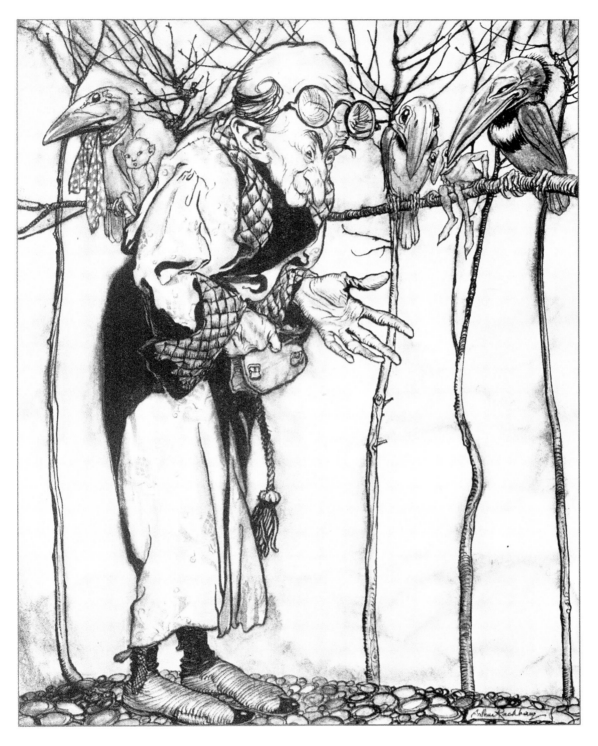

The Wizard

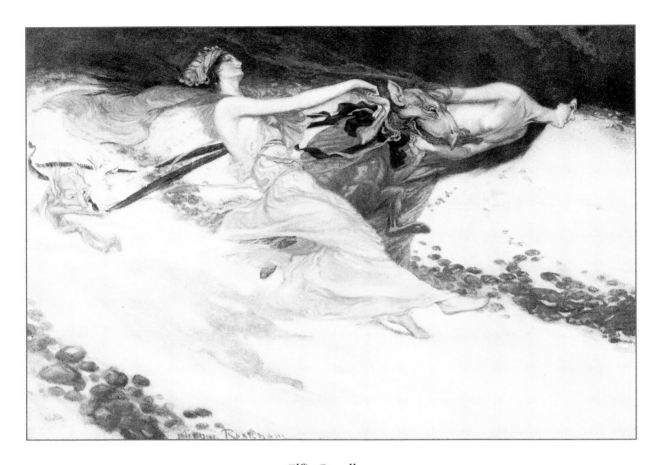

Elfin Revellers

PLATE 53 Arthur Rackham's Book of Pictures

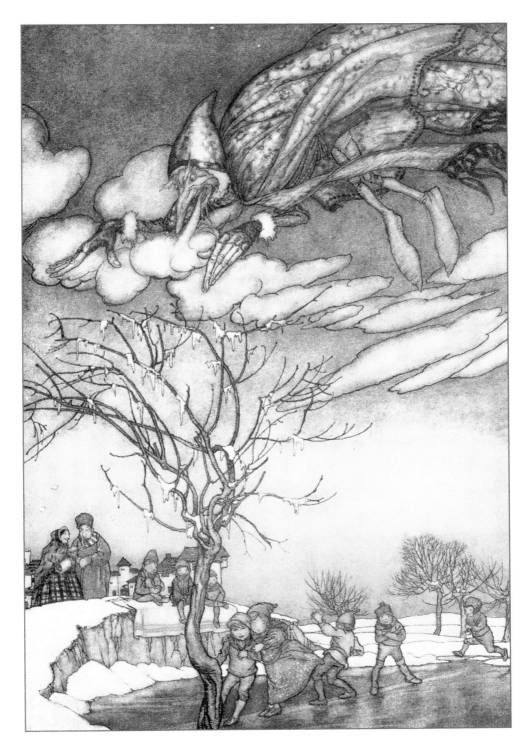

Jack Frost

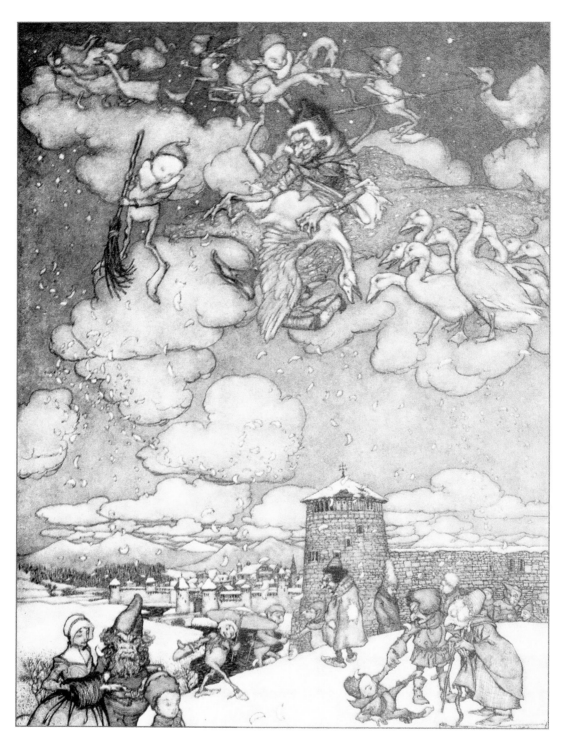

Mother Goose

PLATE 55 Arthur Rackham's Book of Pictures

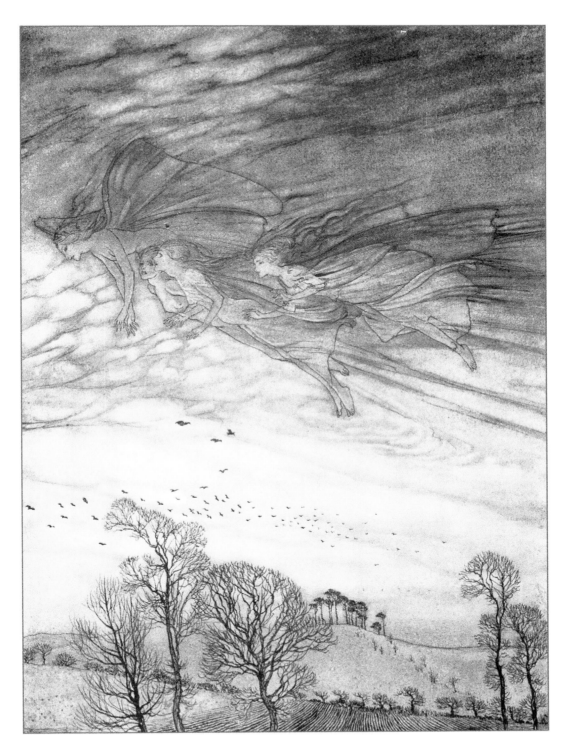

Shades of Evening

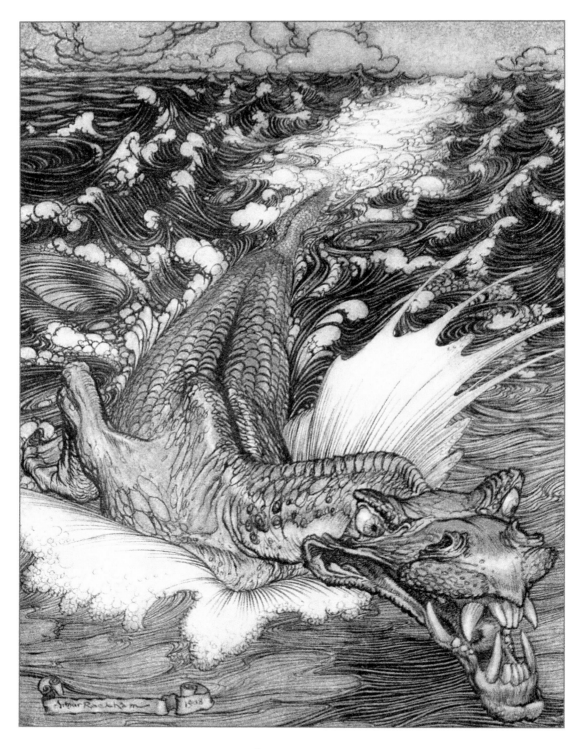

The Leviathan

PLATE 57 Arthur Rackham's Book of Pictures

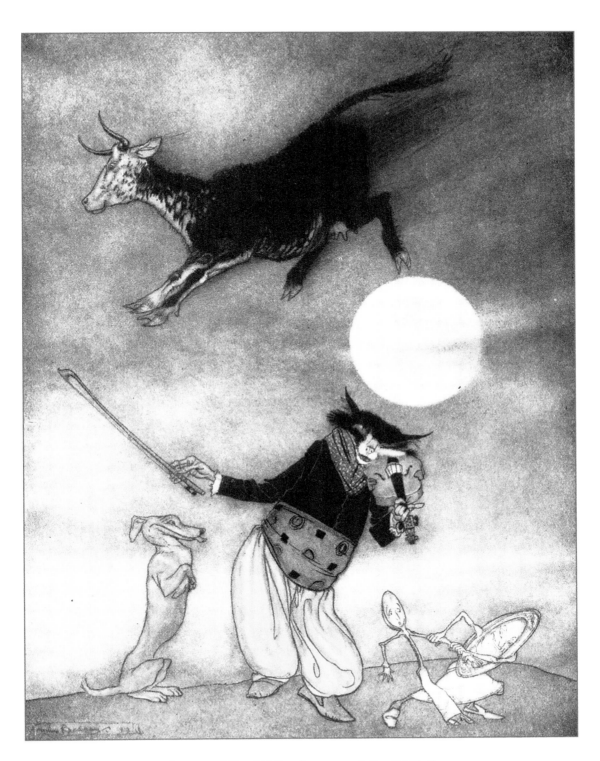

"Hey! Diddle, diddle, the cat and the fiddle!"

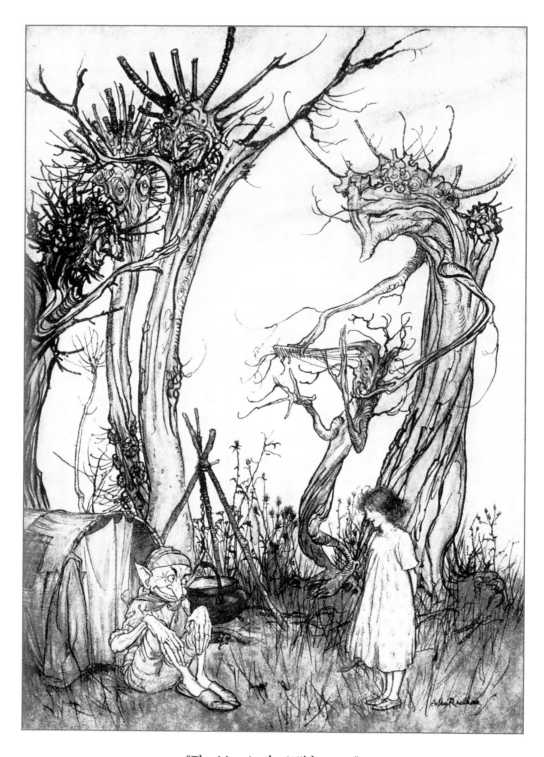

"The Man in the Wilderness"

PLATE 59 Mother Goose

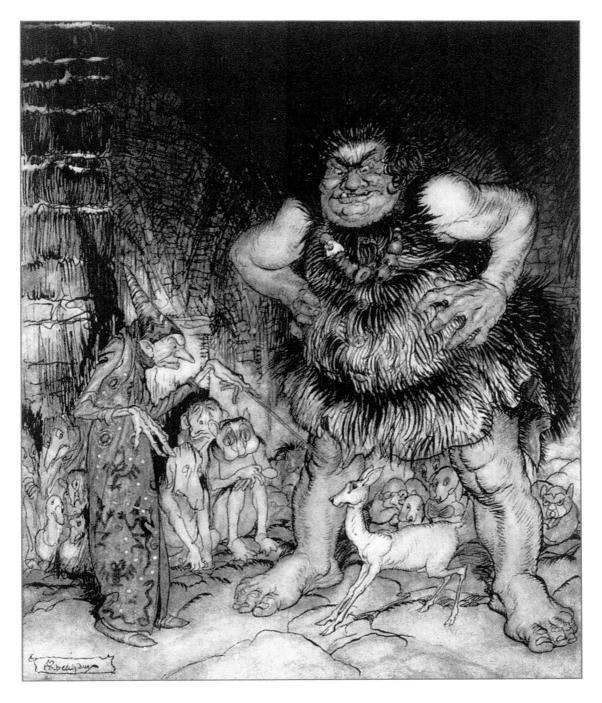

The giant Galligantua and the wicked old magician transform the duke's daughter
into a white hind.

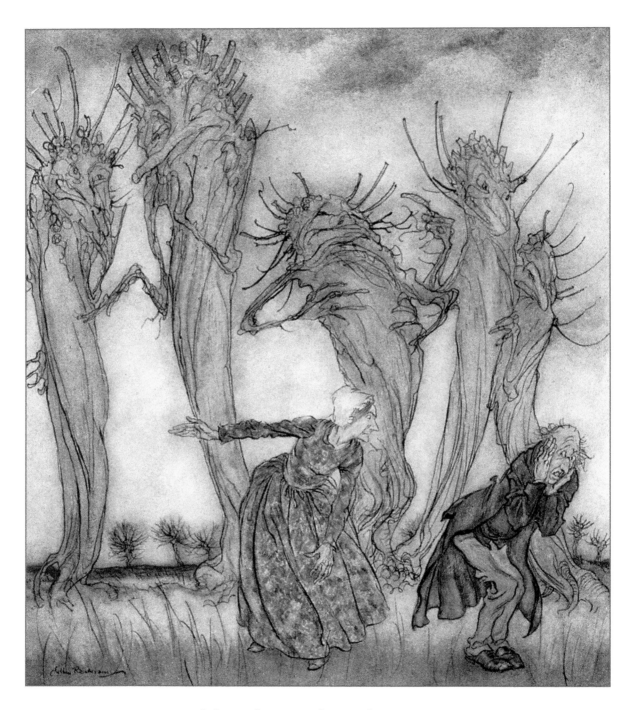

And that is the story of Mr. and Mrs. Vinegar.

PLATE 61 English Fairy Tales

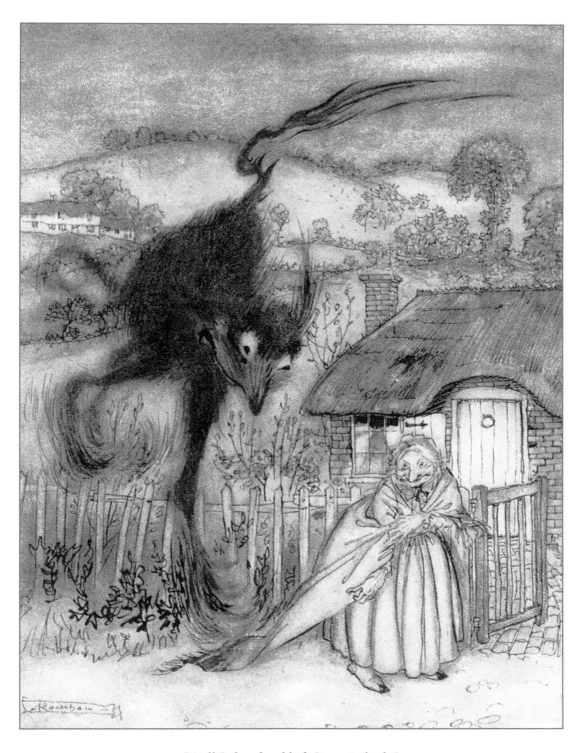

"Well!" she chuckled, "I am in luck!"

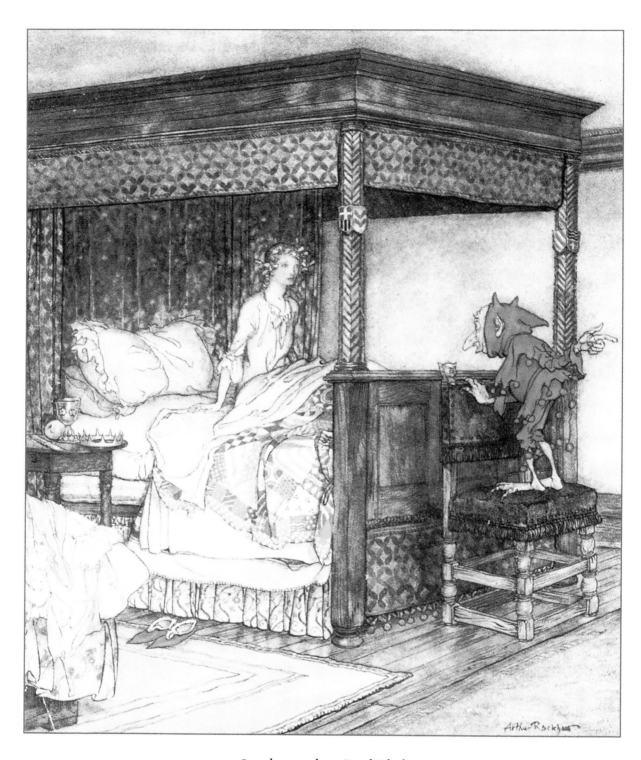

O waken, waken, Burd Isbel

Plate 63 Some British Ballads

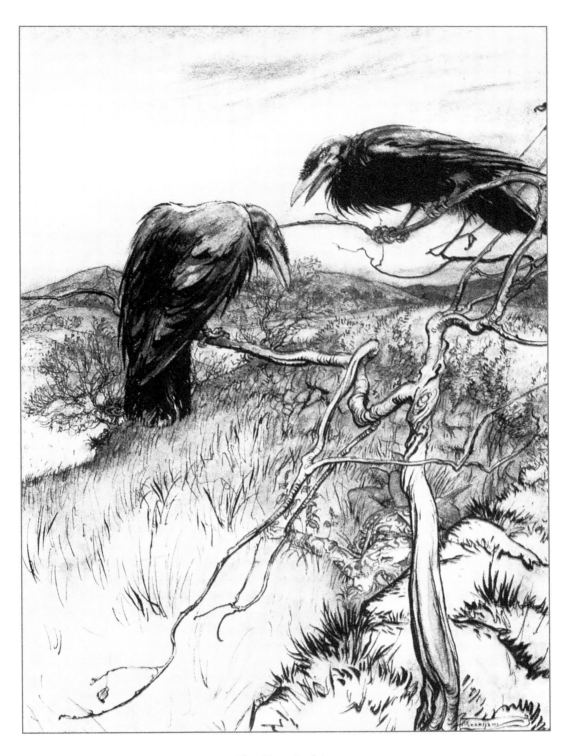

The Twa Corbies

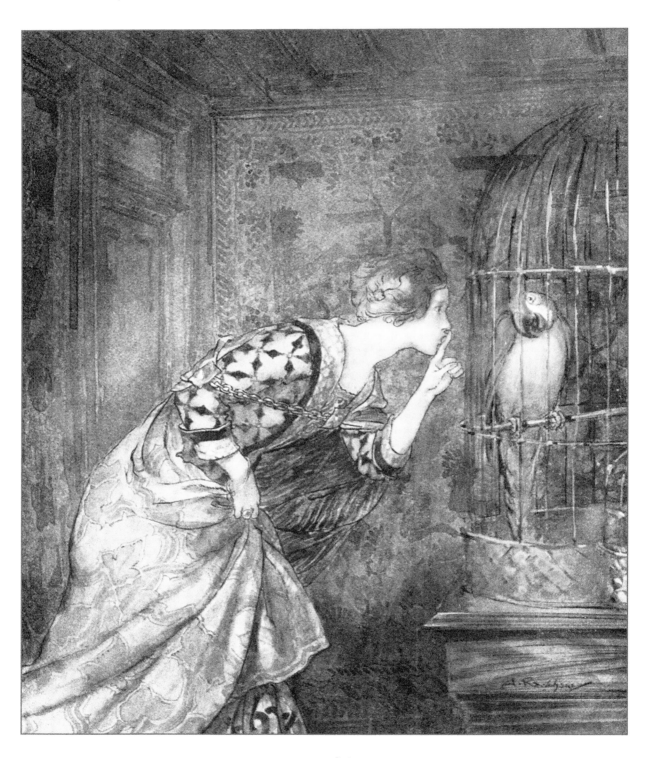

May Colvin

PLATE 65 Some British Ballads

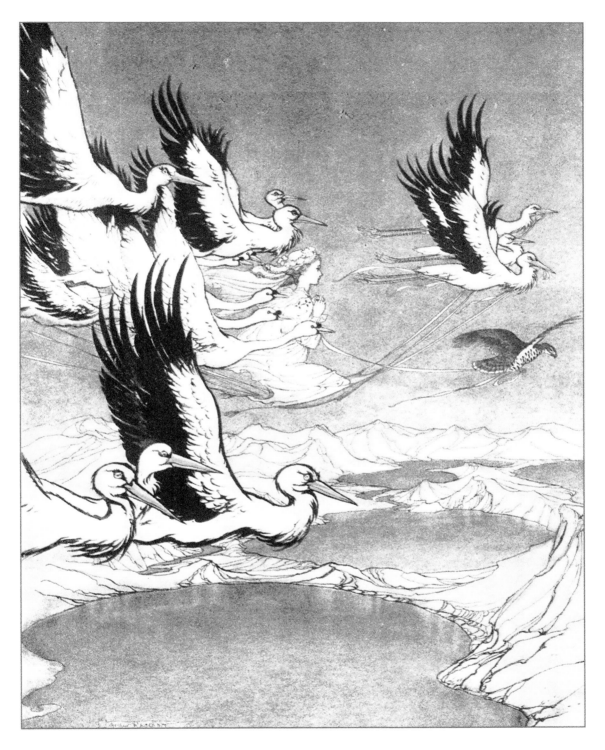

Earl Mar's Daughter

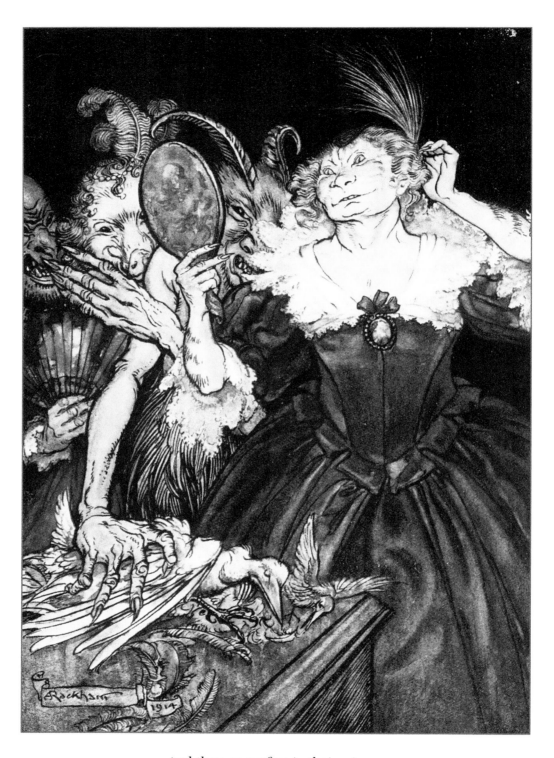

And they, so perfect in their misery,
Not once perceive their foul disfigurement,
But boast themselves more comely than before.

PLATE 67 Comus

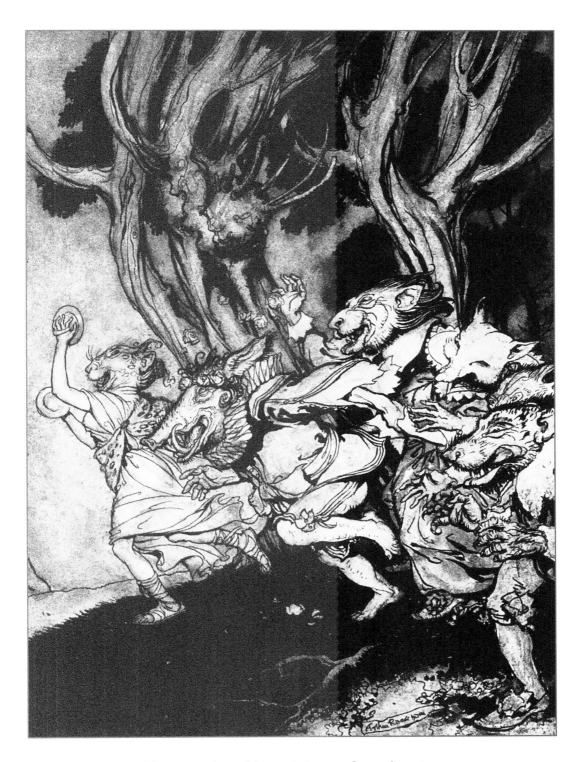

They come in making a riotous and unruly noise.

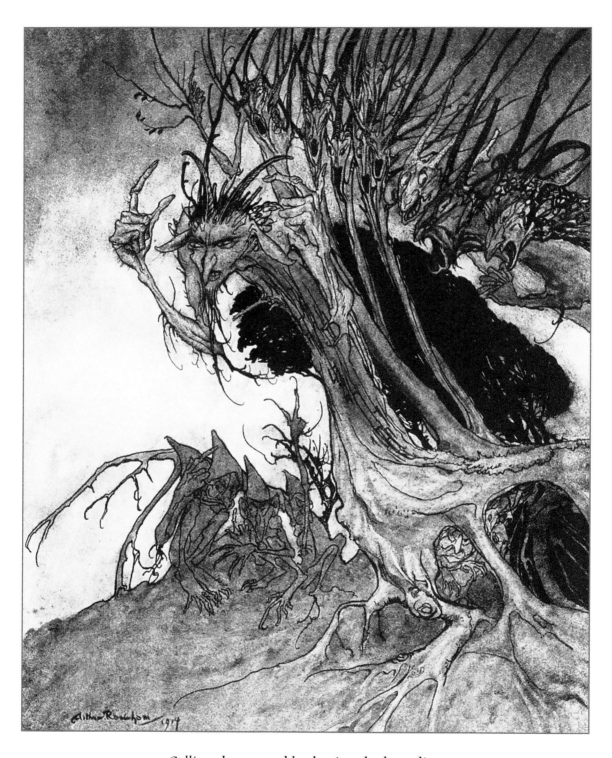

Calling shapes, and beckoning shadows dire.

PLATE 69 Comus

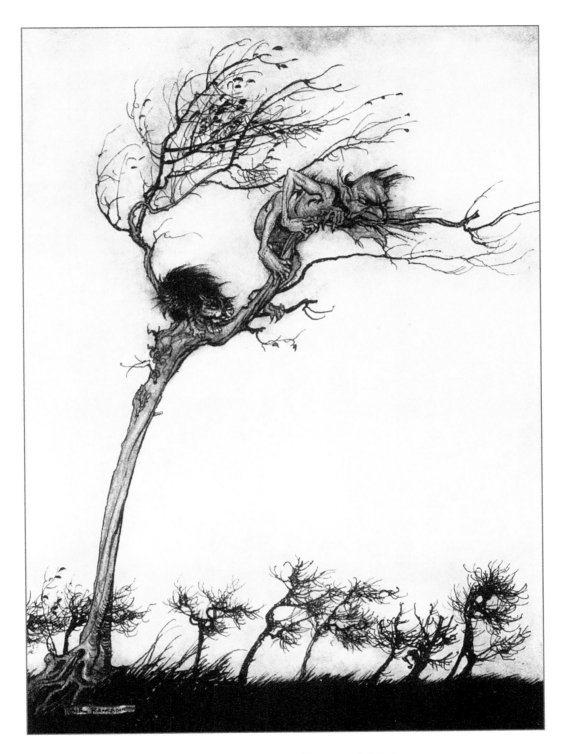

Blew meager Hag, or stubborn unlaid ghost
That breaks his magick chains at curfeu time

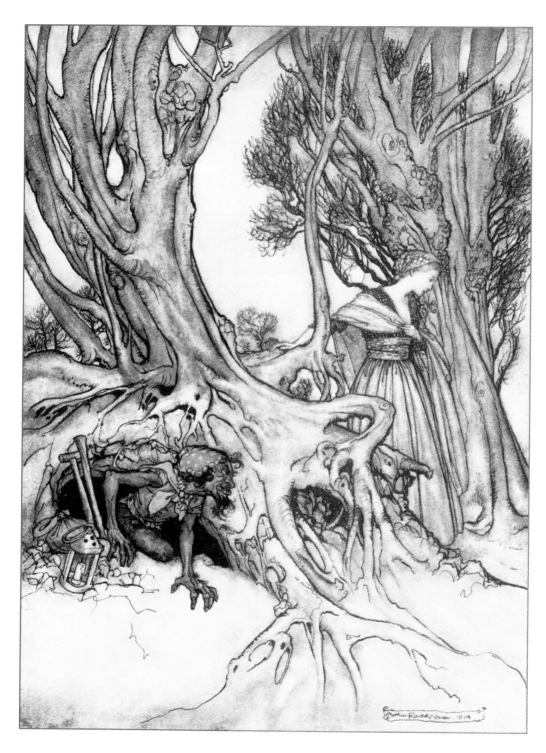

No goblin, or swart faery of the mine,
Hath hurtfull power o're true virginity.

PLATE 71 Comus

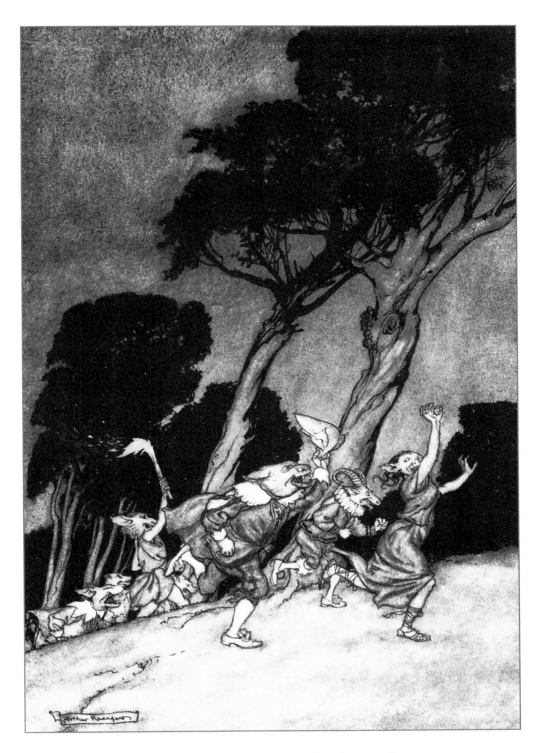

The wonted roar was up amidst the Woods,
And fill'd the Air with barbarous dissonance.

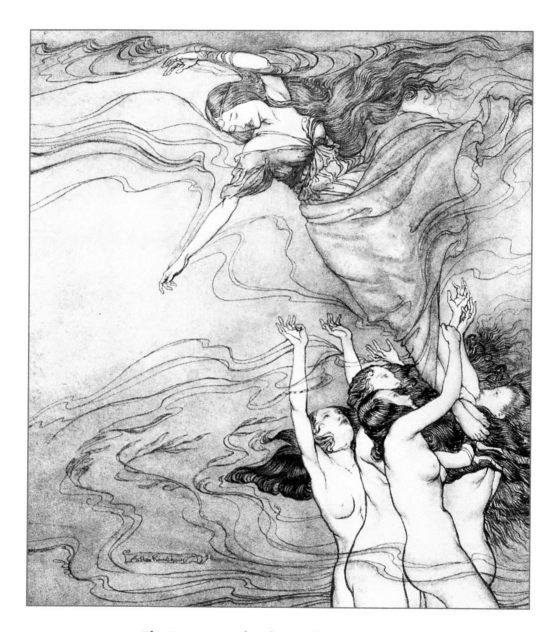

The Water Nymphs, that in the bottom plaid,
Held up their pearled wrists and took her in.

PLATE 73 Comus

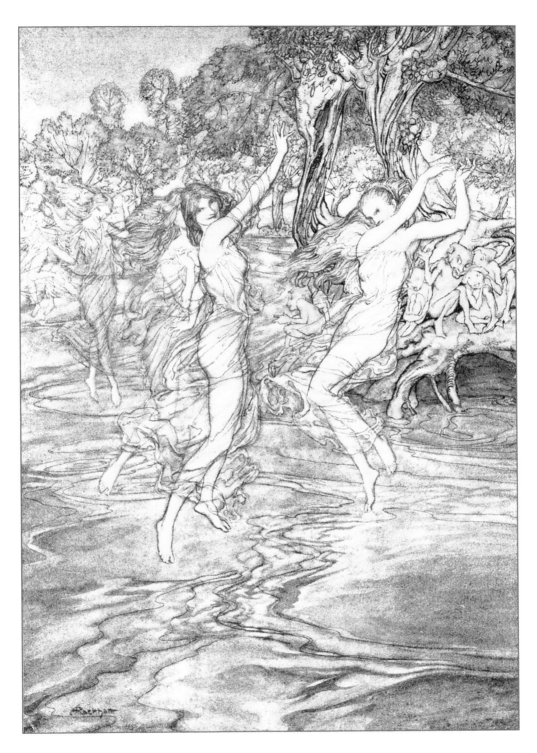

By all the Nymphs that nightly dance
Upon thy streams with wily glance

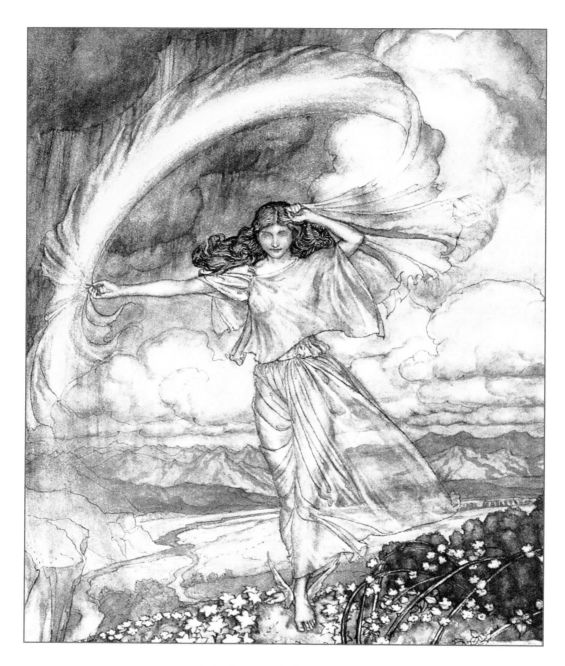

Iris there, with humid bow.

PLATE 75 Comus

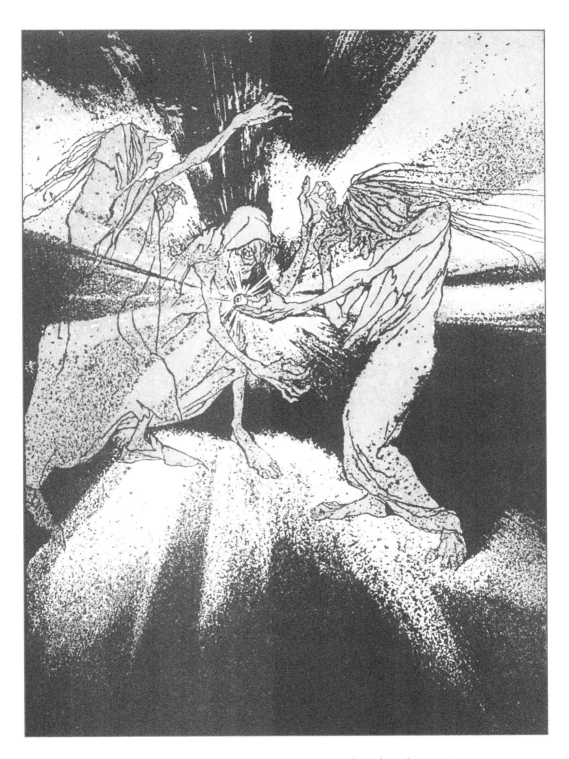

Both Nightmare and Shakejoint put out their hands groping
eagerly to snatch the eye out of the hand of Scarecrow

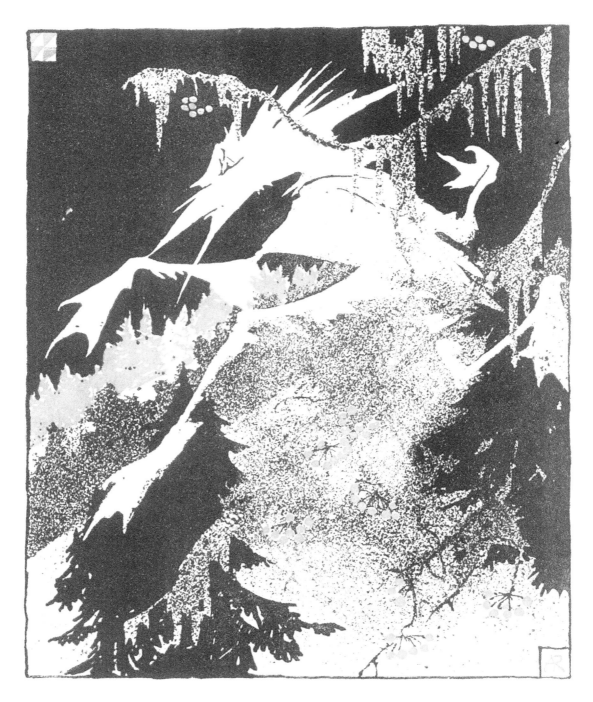

Frost

PLATE 77 A Wonder Book

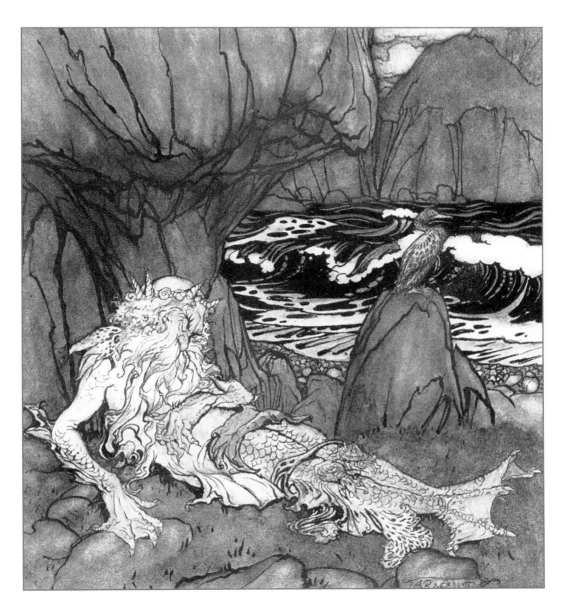

The Old Man of the Sea

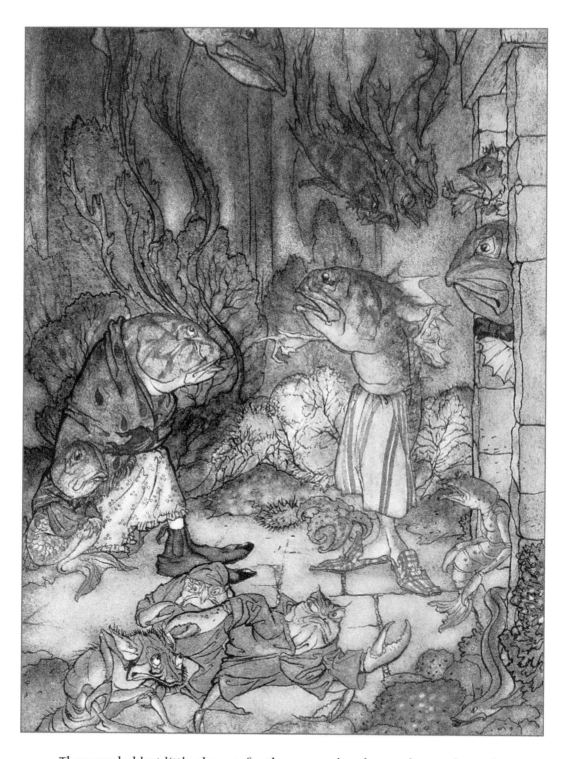

They needed but little change, for they were already a scaly set of rascals.

PLATE 79 A Wonder Book

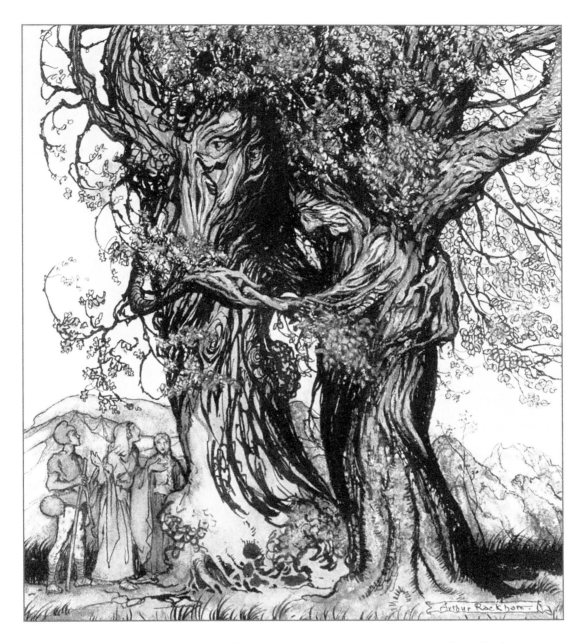

"I am old Philemon!" murmured the oak. "I am old Baucis!" murmured the linden-tree.